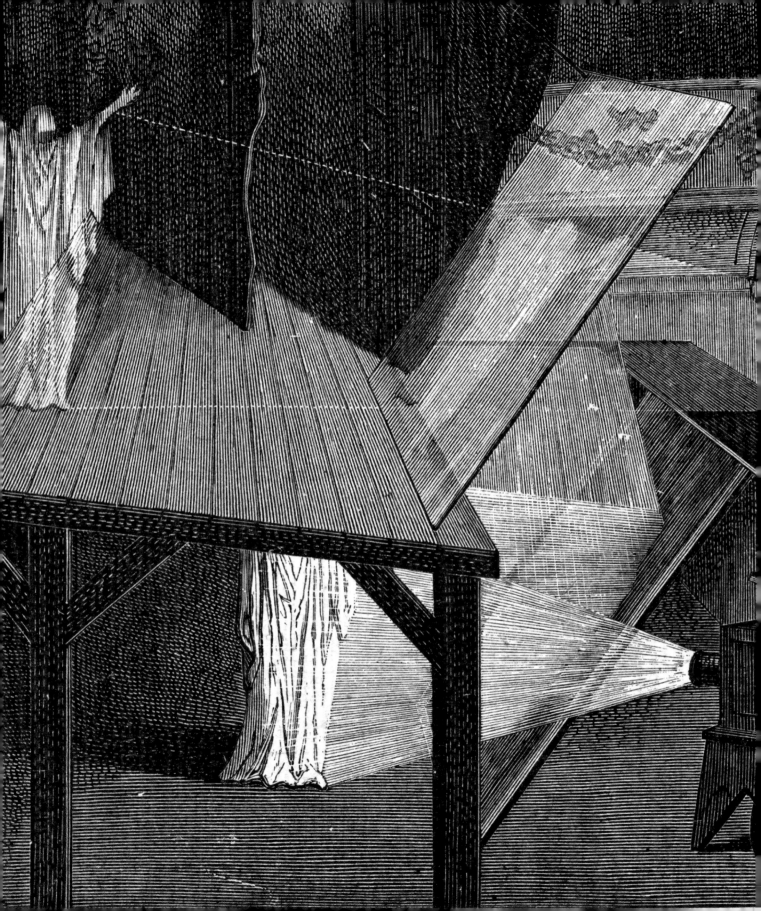

CHRISTIAN BOLTANSKI

JIM CAMPBELL

MICHEL DELACROIX

LAURENT GRASSO

JEPPE HEIN

WILLIAM KENTRIDGE

RAFAEL LOZANO-HEMMER

TERESA MARGOLLES

OSCAR MUÑOZ

JULIE NORD

ROSÂNGELA RENNÓ

REGINA SILVEIRA

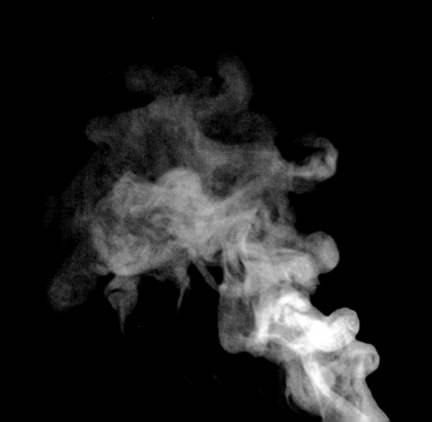

phantasmagoria

SPECTERS OF ABSENCE

JOSÉ ROCA

WITH A SHORT STORY BY

BRUCE STERLING

INDEPENDENT CURATORS INTERNATIONAL
NEW YORK

Published to accompany the traveling exhibition *Phantasmagoria: Specters of Absence*, co-organized by iCI (Independent Curators International), New York and the Museo de Arte del Banco de la República, Bogotá, Colombia, and circulated by iCI

Exhibition curated by José Roca

EXHIBITION FUNDERS
The exhibition, tour, and catalogue are made possible, in part, by the iCI Exhibition Partners and the iCI independents.

EXHIBITION ITINERARY*
Museo de Arte del Banco de la República
Bogotá, Colombia
March 7–June 11, 2007

The Contemporary Museum
Honolulu, Hawaii
August 31–November 25, 2007

McColl Center for Visual Art
Charlotte, North Carolina
February 8–April 26, 2008

The John and Mable Ringling Museum of Art
Sarasota, Florida
May 22–August 10, 2008

University of Southern California Fisher Gallery
Los Angeles, California
September 3–November 8, 2008

* *at time of publication*

iCI (Independent Curators International)
799 Broadway, Suite 205
New York, NY 10003
Tel: 212-254-8200 Fax: 212-477-4781
www.ici-exhibitions.org

Library of Congress: 2007924756
ISBN: 978-0-916365-76-9

Editor: Stephen Robert Frankel
Designer: Gina Rossi
Publication Coordinator: Frances Wu
Printer: CS Graphics Pte Ltd., Singapore

front cover: ROSÂNGELA RENNÓ, *Experiencing Cinema*, 2004 (detail of installation). page 1: "Pepper's Ghost" effect, 1860s (detail of image on p. 12). page 2: TERESA MARGOLLES, *Aire* (*Air*), 2002 (detail of image on p. 19). page 4: REGINA SILVEIRA, *Transitorio / Durevole* (*Transitory/Lasting*), 1997 (detail of image on p. 38). back cover: WILLIAM KENTRIDGE, *Shadow Procession*, 1999 (video still)

contents

foreword and acknowledgments

More than two centuries ago, long before blockbuster exhibitions drew large crowds to museums, audiences were awed by traveling shows called "phantasmagoria," in which familiar scenes and stories were performed with the use of magic lanterns and rear projections to create dancing shadows and frightening theatrical effects. These events provided a space for thinking about the otherworldly, especially viewers' anxieties regarding death and the afterlife. Those same concerns are still with us today, and a comparable trend can be seen in works by some contemporary artists, who create ghostly images to reflect on notions of absence and loss, often using ephemeral, immaterial mediums such as shadows, fog, mist, and breath.

Phantasmagoria: Specters of Absence presents works by twelve diverse artists, younger as well as established, from seven countries on three continents, attesting to the breadth of interest in the ideas and issues raised by this exhibition. Their various approaches, alternatively festive, mysterious, or ironic, pique the viewers' interest and invite them to consider the often somber implications of the subject matter. Employing a wide range of resources—from simple, traditional materials such as ink on a wall to highly complex technical installations utilizing digital media—these artists have created poetic and thought-provoking works that explore the power of visual images to touch our innermost feelings about the fundamental questions of life.

The catalogue and traveling exhibition have been made possible through the encouragement, dedication, and generosity of many people. First and foremost, on behalf of iCI's Board of Trustees and staff, I extend our sincere gratitude and appreciation to the distinguished curator of the exhibition, José Roca,

LAURENT GRASSO, *Untitled (Projection)*, 2005
(detail of image on p. 24)

director of arts at the Banco de la República, Bogotá, Colombia, with whom it has been a pleasure to work. With intelligence, sensitivity, and persistence, he has brought together a selection of engaging and provocative objects and images on a fascinating subject. He has also contributed an absorbing essay that brings us greater insight into the philosophical, aesthetic, and historical aspects of the works in the exhibition, their compelling presence, and their significance within contemporary art practice.

This exhibition was co-organized by iCI and the Museo de Arte del Banco de la República, Bogotá, Colombia. I want to express iCI's delight with our collaboration, and thank the cultural branch of the Banco, its cultural vice-president, Darío Jaramillo, and Ángela Pérez, director of the Biblioteca Luis Ángel Arango, for their enthusiastic support of the project. It is particularly gratifying for José Roca and iCI to see the exhibition, with works by artists from several Latin American countries, begin its tour in Bogotá, at the Museo de Arte de la República, before it goes to Honolulu and then travels across North America.

We are pleased to have the opportunity to include in this book a new short fiction piece, "The Phantoms of the Colosseum," written especially for this publication by cyberpunk author Bruce Sterling. I take this opportunity to thank him for this generous contribution, which serves as an enriching complement to the exhibition.

I join the curator in expressing our gratitude to all the artists in this exhibition, and to voice particular appreciation for their special efforts to make this show possible. We are also indebted to the lenders who have generously allowed their works to travel throughout the two-year tour, and to the iCI Exhibition Partners and the iCI independents for their support of the exhibition, tour, and catalogue.

On behalf of José Roca, I am very pleased to offer thanks to the Banco staff members who provided crucial assistance in planning the exhibition, producing an accompanying brochure in Spanish for the show's presentation in Bogotá, and designing its installation there: Carlos Betancourt, curatorial assistant; Luis Fernando Ramírez, exhibition designer; Fernando Cruz, photographer; and Fredy Chaparro, graphic designer. He also warmly acknowledges the generous assistance of Karen Gallagher, assistant to Jim Campbell; Natalie Dembo and Anne McIlleron, assistants to William Kentridge; Stephan Babendererde, assistant to Jeppe Hein; Martine Aboucaya, director of Galerie Martine Aboucaya in Paris; Christine Buhl Andersen, curator at the Danish Arts Agency,

Copenhagen; Marcos Gallon at Galeria Vermelho, São Paulo; Anja Schneider at Marian Goodman Gallery, Paris; Bryce Wolkowitz, Bryce Wolkowitz Gallery, New York; Julián Zugazagoitia, director, El Museo del Barrio, New York; and Adriana Hurtado, who provided José Roca with support and insights throughout the entire process.

Sincere appreciation is due to Gina Rossi for her graphic design of this book, and to Stephen Robert Frankel, the book's editor. It was a great pleasure to work once again with these superb professionals. Thanks also go to Alex Ross, for his translation of José Roca's essay.

iCI's dedicated, knowledgeable, and enthusiastic staff deserves recognition for their work on every aspect of this project, which included securing loans, developing the tour, arranging packing and shipping, and creating this publication. Thanks for this work go especially to Susan Hapgood, director of exhibitions; Rachel May, registrar; Sarah Fogel, interim registrar; and Frances Wu, curatorial assistant. Thanks also to Maia Gianakos, curatorial assistant; and Sue Scott, communications and operations manager, as well as to exhibitions intern Jennifer Yee, and former interns Matt Hackett and Simone Grant. I also want to express my gratitude to Hedy Roma, director of development, to Hilary Fry, grants and membership coordinator, and to Collyn Hinchey, development assistant, for their fund-raising efforts.

Finally, I extend my continuing appreciation to iCI's Board of Trustees for their steadfast support, enthusiasm, and commitment to all of iCI's activities. They join me in expressing our gratitude to everyone who has contributed to making possible this challenging and gratifying project.

JUDITH OLCH RICHARDS
EXECUTIVE DIRECTOR

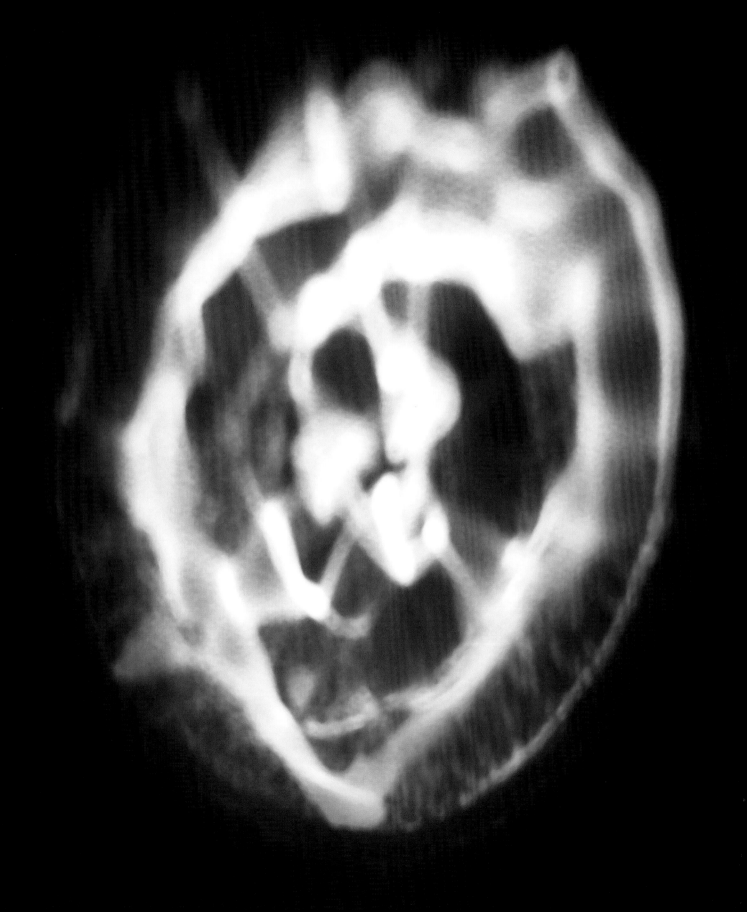

phantasmagoria: specters of absence

JOSÉ ROCA

"THE EXPERIMENT WHICH YOU ARE ABOUT TO SEE MUST INTEREST PHILOSOPHY. THE TWO GREAT EPOCHS OF MAN ARE HIS ENTRY INTO LIFE AND HIS DEPARTURE FROM IT. ALL THAT HAPPENS CAN BE CONSIDERED AS BEING PLACED BETWEEN TWO BLACK AND IMPENETRABLE VEILS WHICH CONCEAL THESE TWO EPOCHS, AND WHICH NO-ONE HAS YET RAISED."[1]

— ETIENNE-GASPARD ROBERT (A.K.A. ROBERTSON)

Toward the end of the eighteenth century, in the heady atmosphere of post-revolutionary Paris, a spectacle concerned primarily with the theme of death and the beyond managed to capture the popular imagination on a massive scale. The phantasmagoria[2]—created by Belgian inventor and showman Etienne-Gaspard Robert (1764–1837), better known as Robertson—is considered the most important of a series of theatrical extravaganzas that attracted huge audiences throughout much of Europe during the eighteenth and nineteenth centuries, especially in France and England.[3] In these blockbuster performances, optical techniques (mostly sophisticated advances on the magic lantern, an early form of optical projector) were combined with various stage effects to seduce an impressionable public with illusory images that alluded to the macabre and fleeting nature of earthly existence. Using the camera obscura, optics, and mirrors, in addition to numerous theatrical and circus techniques, Robertson achieved very realistic effects in a pre-cinematographic period when the public was not yet accustomed to the moving projected image.[4] He was an extravagant character who employed all the resources at his disposal in order to produce overwhelming effects that would astonish his public: the phantasmagoria was presented in spaces adorned with gothic elements, mise-en-scènes similar to those in many of today's theme parks.[5] The spectacle depended as much on

MICHEL DELACROIX, *Lisetta, Ferdinand, Saverio, Edward,* 1995 (detail of installation)

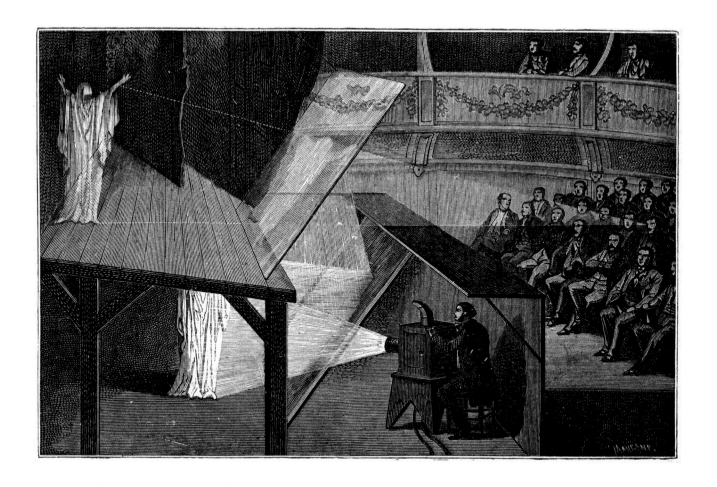

"Pepper's Ghost" effect, projected on a stage
before an audience, 1860s, from Alfred Molteni,
*Instructions Pratique sur l'emploi des Appareils
de Projection; Lanternes Magique, Fantasmagorie,
Polyoramas Appareils pour l'einseignement et pour les
agrandissement* (Paris, 1892)

the internal conditioning of the spectators—by triggering their deepest fears
and superstitions—as it did on the visual, auditory, and even olfactory effects
to which they were skillfully subjected by Robertson and his team of collabora-
tors: images projected onto curtains of smoke, onto veils, or onto glass with
the aid of mirrors; ghostly music produced by a glass harmonica;[6] incense, sulfur,
or other odorific substances that induce disorientation and dizziness; and star-
tling sounds—all of these conspired to produce a very powerful sensation of
the macabre that both terrified and fascinated the spectator.[7]

Robertson's *Phantasmagoria* was the most elaborate version of a genre
of traveling shows in which stories were performed with the aid of magic lan-
terns and rear projections to create dancing shadows and frightening theatrical
effects.[8] These lively, interactive events incorporated storytelling, mythology, and
theater in a single art form that entertained while providing a space for reflection
on the otherworldly—playing with the visitor's anxieties regarding death and the
afterlife. Most phantasmagoria impresarios were very careful to clearly establish

that what they were offering was a spectacle of illusionism and not a spiritual séance or a connection with the occult.[9] The fictitious nature of the spectacle was always made explicit, very probably in order to avoid accusations of blasphemy in a period that had recently suffered the horrors of witch hunts and the bloody repressions of the French "Reign of Terror," or charges of fraud on the part of legal authorities. Consequently, the success of the phantasmagoria was due to a voluntary suspension of disbelief, a willingness to let oneself be seduced by the simulacrum. Perhaps because of these factors, the term "phantasmagoria" evolved over time, ceasing to refer exclusively to the lantern shows, and in common parlance began to refer more generally to the illusory, the unreal, and the imaginary.[10] As a result, the clear separation of categories regarding "ghost seeing," perceiving, and the very act of thinking began to be subverted.

As American scholar Martha Helfer has observed, "The Phantasmagoria served both rational and irrational imperatives. It enlightened the public about the technological apparatuses it employed in order to demystify the genesis of optical illusions, but at the same time succeeded in mystifying the entire interior apparatus of human perception itself. It helped to subjectivize vision by means of 'objective' proof about the inherently deceptive nature of human perception."[11] The phantasmagoria, then, was a spectacle that created an illusion and concealed the devices that were employed to make it possible, and yet an integral part of the spectator's experience was the awareness that such devices were being used. American film scholar Tom Gunning has remarked that "the radical possibilities of the phantasmagoria might be summarized by describing it as an art of total illusion that also contained its own critique":[12] the *vanitas* that signifies the transitory nature of earthly life also accepts its condition as simulacrum. "By the end of the nineteenth century, ghosts had disappeared from everyday life, but . . . human experience had become more ghost-ridden than ever. Through a strange process of rhetorical displacement, thought itself had become phantasmagorical."[13]

As indicated above, the common definition of phantasmagoria posits it as a "shifting series of phantasms or imaginary figures, as seen in a dream or fevered condition, as called up by the imagination, or as created by literary description."[14] Walter Benjamin, employing the concept of phantasmagoria in his *Arcades* project to refer to the commodity fetish—an object in which there is no trace whatsoever of the labor used to produce it—signaled the dialectical oscillation that phantasmagoria elicits: "In using the term, Benjamin was simultaneously evoking both aspects of the experience of phantasmagoria: both spectacle

of movement and the requirement to look beyond surface appearances to the means of their production."[15] Although the term has evolved to describe modes of reality descended from optics and psychology, its atavistic meaning still has currency in contemporary visual production. The artists who created the works in this exhibition use forms of representation in the tradition of the spectacles of fantasy and magic produced by the phantasmagoria impresarios, but reframe them around contemporary issues. These works play with perception and phenomenological experience, often seducing viewers with haunting images before the disturbing implications of those images are understood. In the spirit of Benjamin, these artists want viewers to look beyond the often illusory appearance of the images and delve into the more complex aspects of the artists' reflections on death, loss, and disappearance, and thus try to involve the viewers by means of perceptual shifts, physical engagement with the work, and sheer visual deception.

The representation of shadows has been present in art almost since its inception, but the use of actual shadows as an integral component of the work of art is a rather recent trend. The shadow—literally, the blocking of light—has often been used in art (and in literature) to allude to death, the obscure, and the unnamable, as well as to construct allegories of loss and disappearance, evoking something that is beyond the object yet inseparable from it. Intangible materials that have been used in some modern or contemporary art are mist, breath, fog, and smoke, elements often associated with mystery; falling into a category between fully perceptible and almost nonexistent, they can also represent absence. These are the immaterial mediums that have been used to create the ghostly images in *Phantasmagoria: Specters of Absence*, works with loaded, often somber themes, but tempered by approaches that range from the festive to the ironic.

sublime spirits
"DOES [THE SOUL] RESEMBLE A SHADOW, A REFLECTION, A BREATH, OR WHAT?"[16]

Many cultures believe that the soul manifests itself in the form of a vapor or gaseous essence that is released from the body at the moment of death. In fact, the word "spirit" comes from the Latin *spiritus*, which means "breath," and is used to designate the soul as well. Breath, spirit, and death are intimately connected; in many languages, the expression "last breath" refers to the moment when a person dies. Although materials such as smoke, vapor, mist, or breath

are not very common in art, even in the context of the greatly expanded range of forms and mediums in contemporary artistic production, some artists have used these (im)materials precisely because of their transitory and unstable quality in order to create a metaphor for death, absence, or disappearance. In some cases, smoke is the ephemeral support for the projection of images, in a clear reference to the spectacles of phantasmagoria; in others, it is an element that hides images or causes them to disappear. In still others, it is the breath of the viewer that makes the image appear, infusing it with life, if only for a few brief moments.

An example of the latter is *Aliento (Breath)*, 2000,* by Colombian artist Oscar Muñoz. Muñoz has spent many years creating works that deal with the instability of the image and its support. He has made drawings, prints, and projections on water, on mirrors, and on other unstable or changing supports; he has also used water as an "ink" that disappears as it slowly evaporates, taking the constructed image with it, as in his 2003 video projection *Re/Trato* (a play on the Spanish word for "portrait" that can also mean "I try again"). Muñoz's process-based works often require action on the part of the viewer in order for the works to become complete or stable, a condition that keeps them in a precarious equilibrium between existence and invisibility. One example is his series *Narcisos (Narcissuses)*, 1996, in which a self-portrait made in coal dust is screen-printed on the surface of a container full of water until it finally comes to rest on the bottom of the container. The resulting image is the artist's face, distorted by the action of time and the presence of the viewer as an active agent in the fashioning of the final image. *Aliento* features a row of metallic mirrors that project from a wall, just below the height of the viewer, and appear to contain no image at all until the viewer breathes on them. A ghostly image appears for a few brief moments, revealed by the condensation of the viewer's breath, and then quickly disappears. The images are portraits of people who have died—some of them in violent circumstances—taken from newspaper clippings. Muñoz's works not only react to the viewer's action but demand such involvement, at once public and intimate, thereby provoking a reflection on the passivity of the individual in the face of unpleasant social realities and the responsibilities each person has as a social agent.

This presence of death visualized through water vapor is also common in the work of Mexican artist Teresa Margolles; but whereas in Muñoz's work it is the breath emanating from the viewer's body that brings the image of death to the surface, in Margolles' work breath inscribes this presence on the

*Works marked by an asterisk are included in the exhibition; those without an asterisk are not.

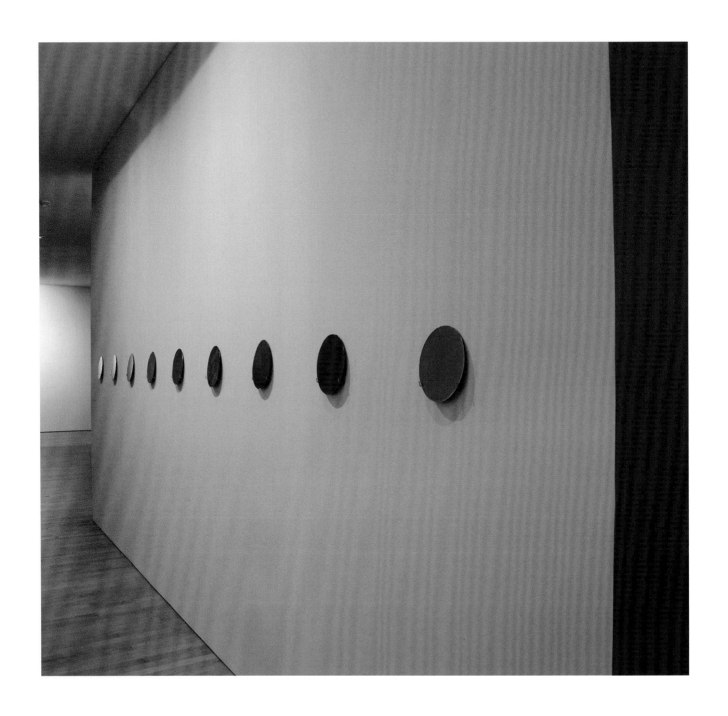

OSCAR MUÑOZ, *Aliento (Breath)*, 2000; installation
view at Museo de Arte del Banco de la República,
Bogotá, Colombia, 2007

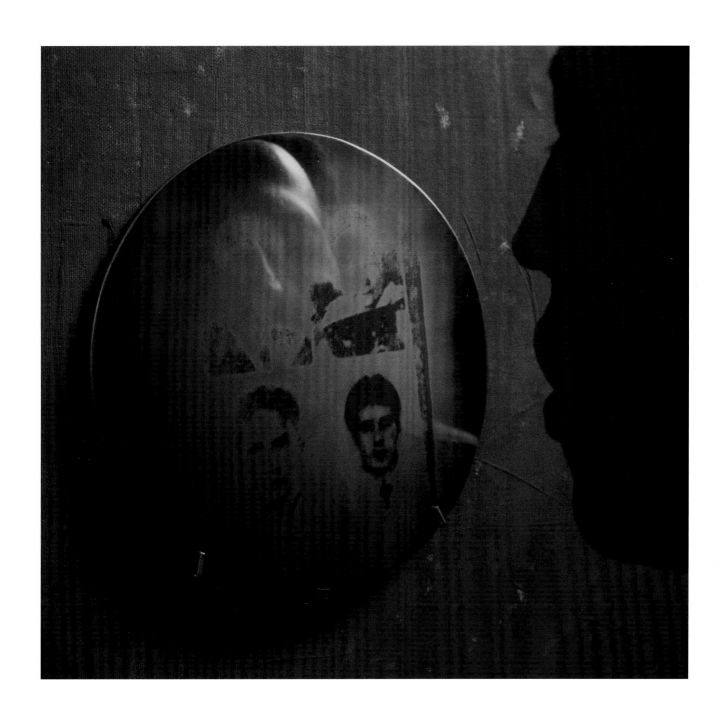

OSCAR MUÑOZ, *Aliento* (*Breath*), 2000
(detail of installation)

viewer's own body. Margolles began working with artificial mist in a piece called *Vaporización (Vaporization)*, 2001. *Vaporización* is set in an empty space where visibility is obscured by a subtle fog that becomes thicker and thicker as the viewer enters the room, until it almost entirely prevents any possibility of seeing. The mist is generated by a simple machine of the type often used to create stage effects. Here, what could otherwise be read as simply a commentary on visibility and its associations (clarity and truth, and their negation) is completely transformed when the viewer discovers that the fog has been created out of water mixed with fluids obtained from a Mexican morgue, by-products of the cleaning of corpses after autopsies have been performed. Margolles' *Aire (Air)*, 2002,* is also based on the idea of vapor as a metaphor for the absent body, in this case using a series of mobile humidifiers, like those commonly used in museums and offices. Rising from each one is a tenuous column of vapor, which could be read as the spirit or soul of some deceased individual. As in *Vaporización*, the water in each humidifier contains a symbolic proportion of liquid left over from the cleaning of a corpse in a Mexican morgue. By inscribing the traces of the absent body on the body of the viewer, Margolles creates a different kind of specter, not limited to manifestation on the visual field alone. This literal inscription of death on the viewer's body is the most violent and transgressive situation imaginable—invoking "imagination" in both the everyday and etymological senses of the word: to construct a mental image of death. By means of a (perverse) poetic action, the dead body metaphorically returns the gaze of the individual who can no longer be called merely "the observer." Margolles replaces the optical with the haptical, the visual with the tactile, substituting a sensorial experience for purely visual images—perhaps the closest the living can come to being "as one" with a dead body.

Water utilized to create an image is also a component of the work of French artist Michel Delacroix. *Lisetta, Ferdinand, Saverio, Edward*, 1995,* is a sculptural installation consisting of a series of mirrors raised six feet above the floor by thin, delicate tripod bases, each mirror engraved with an eerie face on its surface and covered by a fine layer of water. Light strikes the mirrors, reflecting ghostly images of the faces onto the wall, along with shadowy silhouettes of the tripods. When viewers approach the images to see them up close, their own vibrations cause a deformation of the reflections, blurring and distorting the faces until the features become indiscernible.

Delacroix often uses personal names as titles for his works, as if to suggest the presence of a real person who is now absent. Inherent in his work

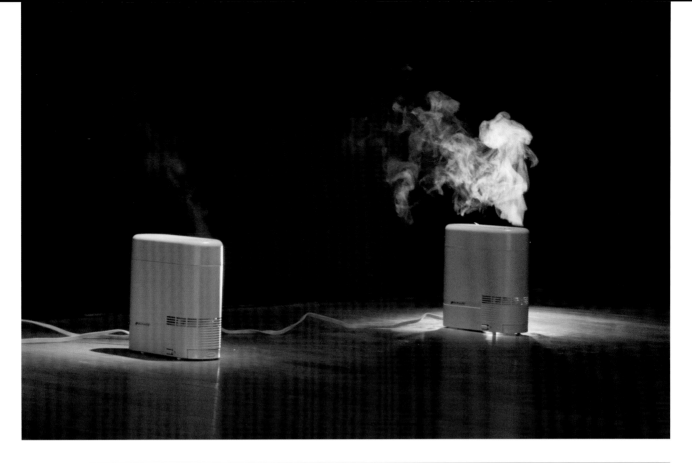

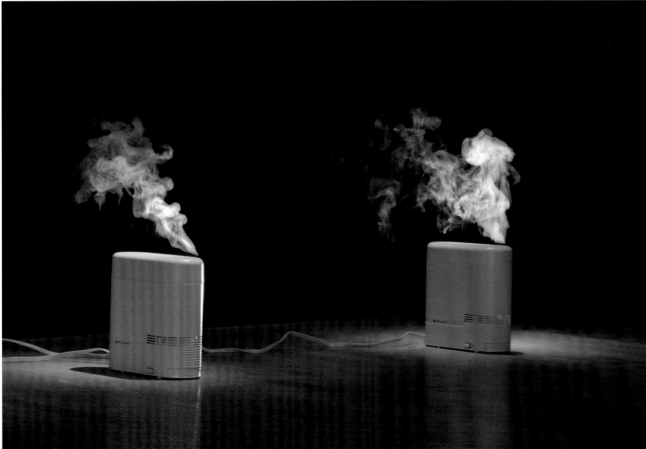

is a constant reflection on human presence, the appearance and disappearance of the figure, and the memory that remains when the figure is no longer present. "There is always a certain ambiguity with regard to presence and absence, and my work is based on this ambiguity. . . . It is a work of interrogation about the person inscribed in history. We are in the genre of the Portrait with questions about existence, about what it is that causes a person or an image to exist, about what causes one person to exist and another to see him or her."[17] In contrast to the work of Muñoz in this exhibition, where the image appears only when one breathes on it, giving it the "breath of life," in Delacroix's work the act of looking is what destroys the image: it can only exist in an integral, recognizable form when one renounces the desire to see it. It is like the spirits in gothic novels or in the phantasmagoria spectacles: apparitions that seem about to assail us but flee or disappear when we attempt to approach them, as if their ephemeral existence as images depends on the distance we maintain with respect to them and what they represent.

The disappearance of the viewer's body is the central theme of *Smoking Bench,* 2003,* by Danish artist Jeppe Hein, an installation work that consists of a large mirror placed in front of what appears to be just a bench, a modern piece of museum furniture. When people sit on the bench, they instinctively look at their reflection in the mirror; and, after a few seconds, a dense cloud of smoke is released from inside the bench, totally engulfing the viewers, who witness their own disappearance. Some seconds later, they will see themselves reappear as the smoke slowly dissolves. Hein (a "sociopsychologist," as curator Francesco Bonami has described him),[18] is well known for his sculptural or environmental works where the viewer activates or interacts with a changing or mutable medium. The fleeting image that *Smoking Bench* presents is that of the viewer him- or herself, thus reversing the experience of the observer of ghosts in the classic phantasmagoria shows. Hein's works create an active spectator, one who becomes implicated with the works in ways that involve the whole body and its senses. This generates in turn an acute consciousness of the body and the self. The factor of surprise in *Smoking Bench* is even more powerful, since the viewer—who is already engaged in a spontaneous act of self-observation—is ultimately forced to reflect on the finite condition of life, and the inevitability of one's own eventual disappearance.

On a projection screen in another room, a dense cloud of fog or dust emerges from the far end of a narrow alley and passes through the streets of Paris, enveloping everything in its path, a menacing presence as in an apocalyptic

above: MICHEL DELACROIX, *Lisetta, Ferdinand, Saverio, Edward*, 1995 (detail of installation)

opposite: MICHEL DELACROIX, *Lisetta, Ferdinand, Saverio, Edward*, 1995; installation view at Museo de Arte del Banco de la República, Bogotá, Colombia, 2007

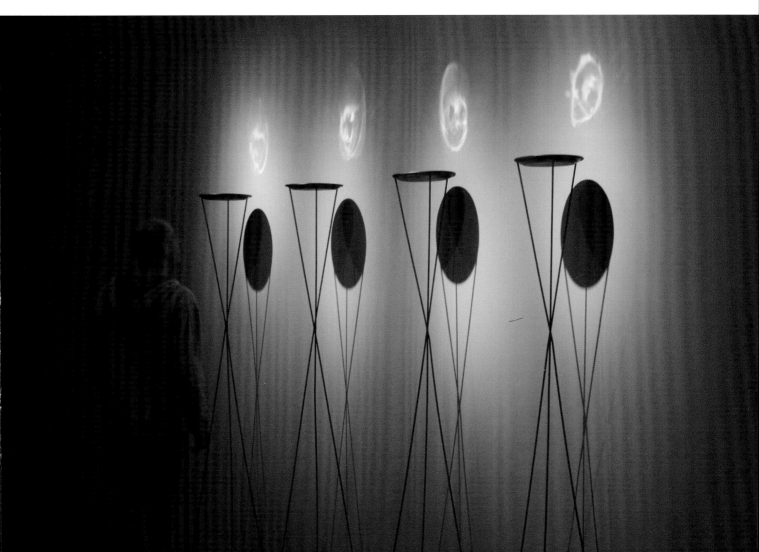

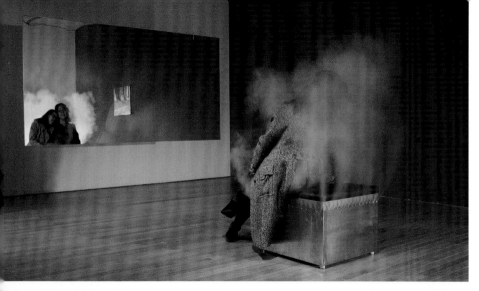

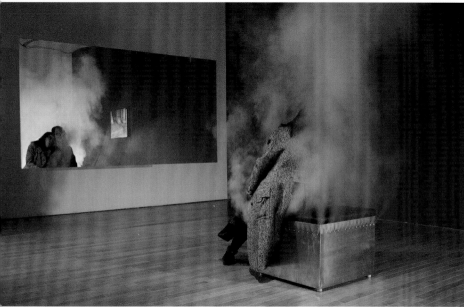

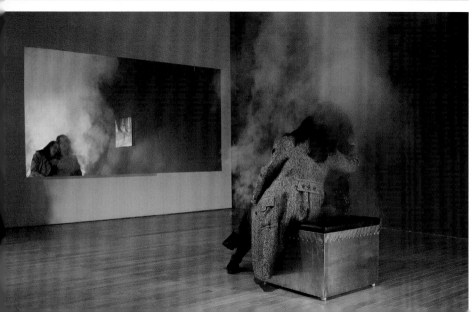

JEPPE HEIN, *Smoking Bench*, 2003; installation view at Museo de Arte del Banco de la República, Bogotá, Colombia, 2007

vision or the aftermath of a disaster, moving forward until it "crosses" through the screen, symbolically engulfing the viewer.[19] Instead of dissipating or expanding as it advances in its inexorable path, it maintains its defined contours that give it the appearance of a distinct being with its own will, and with a chilling uncanniness about it. This is *Untitled (Projection)*, 2005,* by French artist Laurent Grasso, who is interested in the presence of ghosts and other anomalies that interfere with rational discourse. Earlier works by him also display an interest in such phenomena—for example, *Radio Ghost*, 2004, a video work that Grasso made during a visit to China. It shows images of a city (a constructed model) filmed from above, accompanied by fragments of conversations by people on the radio or at film-production sites talking about paranormal phenomena, spirits, ghosts, and apparitions.

One of the discoveries made by the early phantasmagorians was that when images are projected on a curtain of smoke, they acquire an immaterial aspect that coincides with the preconceived notion that spirits dissolve in the air after their brief appearances. This technique is exploited by Brazilian artist Rosângela Rennó, who has analyzed the capacity of images to hold such memories. Rennó often uses stock photographs or photographs from family albums in her work, anonymous images that would have otherwise been condemned to oblivion. Using pre-existing images allows her to reflect on the cultural use of the human image as well as on the perceptual and communicative limitations of their legibility. For example, in Rennó's *Serie vermelha* (*Red Series*), 2001–3, which consists of images of men and children dressed in military uniforms, many of the photographs come from flea markets, images that have entered the public domain after being forgotten, detached from their original identity and affiliation. Rennó has digitally modified the images in terms of their definition as well as their color, to the point where their features are hardly recognizable—a "thinning" of the image to its minimum communicative density. In *Experiencing Cinema*, 2004,* the thinning of the image is achieved by replacing the usual support—paper—with the almost immaterial, temporary, and unstable support of a curtain of smoke. As Spanish critic Mariano Navarro has noted, Rennó achieves an "evaporation of the image, by the action of thinning it out until it becomes almost transparent. Then, only the spectator's susceptibility (the action of receiving/absorbing something in himself or the aptitude for experiencing a certain effect) will endow a personal content to something that comes to us from the shadows and lights of the past."[20]

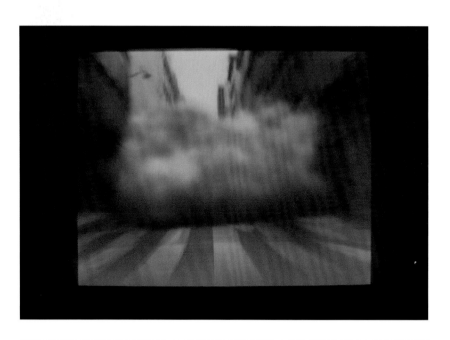

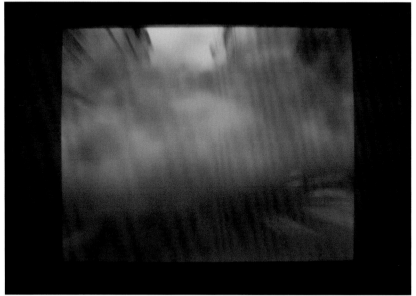

above and opposite: LAURENT GRASSO, *Untitled*
(Projection), 2005; installation view at Museo de Arte
del Banco de la República, Bogotá, Colombia, 2007

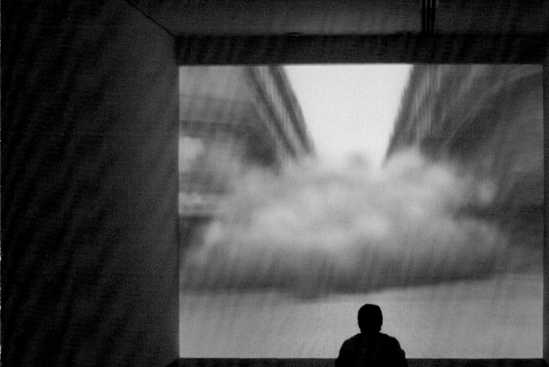

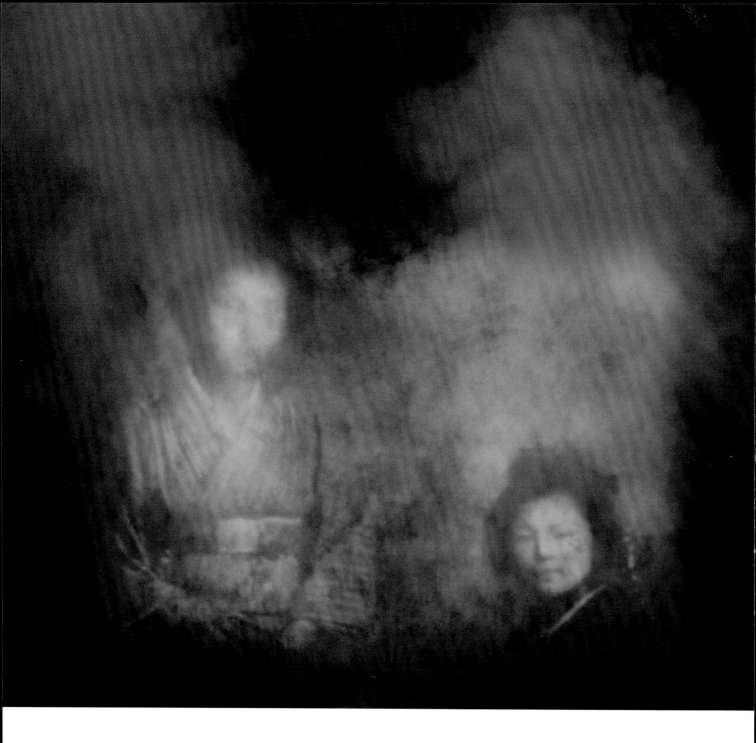

above: ROSÂNGELA RENNÓ, *Experiencing Cinema*, 2004
(detail of installation)

opposite: ROSÂNGELA RENNÓ, *Experiencing Cinema*, 2004

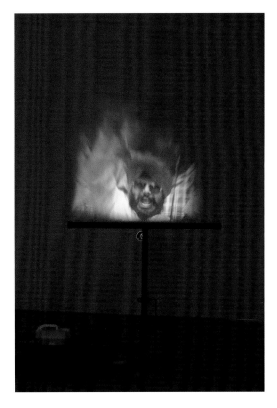

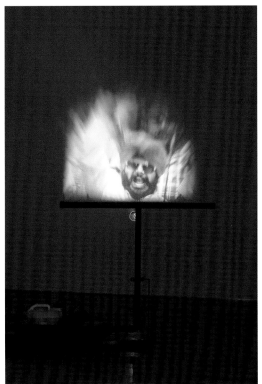

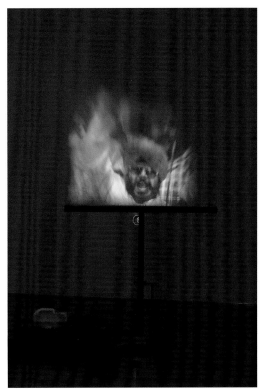

shadow-players and necromancers

"THE SUBJECT, PROJECTED INTO THE FRAME WITH THE WEIGHT OF HIS MATTER, INSCRIBES HIS DOUBLE THERE, ENLARGED AND OF FREE EXISTENCE."[21]

Many of the artists whose works are included in this exhibition delve into the history of the shadow theater, a form of pre-cinematographic moving-image spectacle that was much in vogue during the eighteenth and nineteenth centuries, the origins of which can be traced back to China more than a thousand years ago.[22] This type of spectacle, also called shadow play, used stiff or articulated marionettes and/or actors' bodies to create the illusion of images in motion, and to narrate stories, myths, and legends in this way. In most cultures, some form of shadow theater exists because of the simplicity of the device, which consists merely of a light source and a projection support. In the engraving *The Shadow Dance*, 1675, by Dutch painter Samuel van Hoogstraten, we can see the beginning of shadow theater and its dramatic potential. Depending on their distance from the light source, the projected figures take on sizes that defy the laws of human scale, imbuing their characters with qualities that may range from the angelic to the demonic. The capacity to easily alter the scale of images adds a mode of expressiveness that compensates for the absence of features and color. Such forms could also be created by combining diverse elements that were unified by the homogenizing action of shadow. Both these factors contributed to the frequent association of shadow theater with the unnamable and the unrepresentable—with the mysteries of the beyond.

The tradition of shadow theater has been taken up again by South African artist and theater director William Kentridge. Kentridge is well known for his frame-by-frame film/video using charcoal drawings that he reworks directly on the page in a process of drawing and erasing, so that the drawing itself retains traces of the process and the evolution of the story. In his animations, the figures appear and transmute into objects, dissolve into the landscape, or disappear, leaving faint traces of their presence as if they were spirits, vestiges of facts that remain in the memory even though history attempts to make them disappear. In Kentridge's best-known works, such as *Felix in Exile*, 1994, and *History of the Main Complaint,* 1996, archetypal figures (the industrialist, the everyman, the woman) are the protagonists of haunting stories that have apartheid and social segregation as their context. Kentridge's work explores the issues of individual and collective responsibility and the official construction of history. Always eschewing the easy path of political denunciation, Kentridge

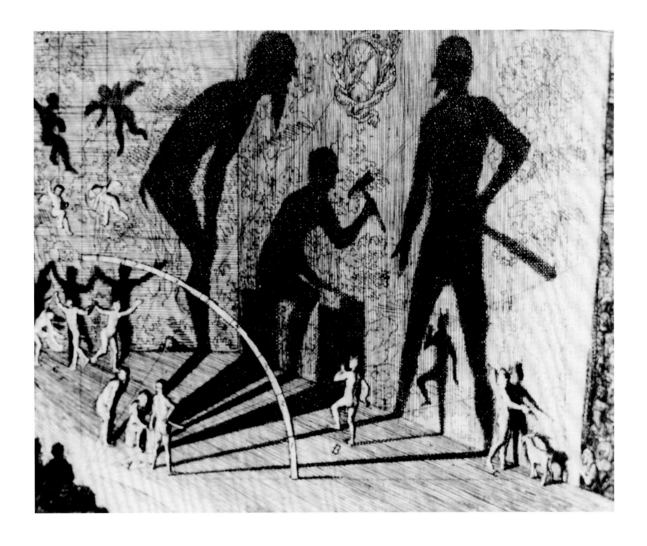

moves the setting of his stories to the personal plane: he emphasizes the pre-
cariousness of human existence by means of the mutability of the image and
the suffering, anxiety, guilt, and loss endured by his characters.

With a background in theater studies, Kentridge has worked as a direc-
tor and as an actor with his theater group, the Handspring Puppet Company.
Many of the group's productions have drawn on resources ranging from shadow
theater to Western literature or drama that reveal parallels between the cultures
of Europe and South Africa, such as *Woyzeck on the Highveld*, 1992 (based on
the character in Georg Buchner's play *Woyzeck*), *Faustus in Africa!*, 1995 (based
on the character in Goethe's play *Doctor Faustus*), *Ubu and the Truth Commission*,
1997 (based on the character in Alfred Jarry's *Ubu* plays), *Il Ritorno d'Ulisse*, 1998
(based on Homer's *Odyssey*), or *Zeno at 4 am* and *The Confessions of Zeno*, 2001

SAMUEL VAN HOOGSTRATEN, *The Shadow Dance*,
1675, engraving in *Inleyding tot de Hooge Schoole
der Schilderkonst* (*Introduction to the Art of Painting*
[Rotterdam, 1678], p. 260)

and 2002 (inspired by Italo Svevo's novel *The Confessions of Zeno*). "Materials from the history of European literature and music are thus put explicitly into a post-colonial context. William Kentridge not only changes the setting into a South African landscape, in which poor Woyzeck is misused for inhuman experiments, or Faust makes a pact with the devil; he also explores to what extent these works reflected, veiled, or furthered the colonial relationships of their time. Hence Alfred Jarry's theatre of the absurd with King Ubu can be a means to keep at a tolerable distance the real horror which the work of the Truth and Reconciliation Commission has to face."[23] Kentridge's *Shadow Procession*, 1999,* is an animated film that shows a seemingly endless procession of displaced people trudging arduously across a barren, desertlike landscape, featuring strange anthropomorphic characters made of cardboard and wire shot frame by frame, as well as a life-size figure (worn in performance by an actor), a wide-open eye, and a cat. The sorrowful singing of Alfred Makgalemele, a street musician from Johannesburg, and the militant songs of the South African insurrection lend great emotional intensity to the scene of exodus. The figures, bent down by effort and fatigue, carry their possessions as they march inexorably forward; they advance toward an unknown destiny—as if on a quest, in flight, or condemned to exile. The desolate African landscape is the setting for this arduous collective migration marked by oppression and suffering. In Kentridge's work, the landscape is presented as the repository of memory, as well as of the repressed in a society that has endured a colonial history of infamy and forced forgetting. The words used by Kentridge to refer to *Felix in Exile* are equally applicable to *Shadow Procession*: "[The work questions] the way in which the people who had died on the journey to this new dispensation would be remembered—using the landscape as a metaphor for the process of remembering or forgetting."[24]

Another artist who makes explicit use of the shadow theater tradition is Christian Boltanski. His cut-tin puppets that cast shadows on the walls recall imagery from the carnival as well as figurines used in some cultures to celebrate the Day of the Dead. Boltanski first came across this device when he was looking for ways to overcome the difficulty of transporting artworks from one exhibition space to the other: "I wanted to work with things that were lighter, things I could put in my pocket. I realized that just by projecting a microscopic puppet I could obtain a large shadow. At last I could travel with the minimum of luggage and work with incorporeal images."[25] In the early 1990s, Boltanski produced a number of works with cut-tin puppets that were lit by various sources, such as

very small lamps, projectors, or candles. Some of them had tiny motors that made the figures dance in eerie movements across the exhibition space, as in *Théâtre d'Ombres* (*Shadow Theater*), 1986; others moved subtly with the changes in the air currents as in *Les Bougies* (*The Candles*), 1987 — a series of tin puppets, each one lighted by a candle — or *L'Ange* (*The Angel*), 1986, a winged figurine with a scythe that hangs from the ceiling, projecting its shadow on the walls and on the viewers and investing the space with its menacing presence wherever the work is displayed.

His *La Danseuse* (*The Dancer*), 1987,* is one of the early examples of this approach. It consists of a figurine attached to a circular metal plate that turns slowly, projecting a shadow onto the walls of a closed space that the viewer can only glimpse through a partially open door. The effect is unsettling, both frightening and self-reflective, as Boltanski notes in describing these early shadow works: "But the shadow is also an inner deception. Do we not say 'to be frightened of one's own shadow?' The shadow is a fraud: it appears to be the size of a lion but is in fact no larger than a microscopic cardboard figurine. The shadow is the representation within ourselves of a *deus ex machina*."[26]

Some of the other works displayed in the exhibition allude to absent bodies that are present only in the "shadows" they supposedly project, as in the case of works by Regina Silveira and Julie Nord. Silveira has carried out an in-depth exploration of light and shadow — and, by extension, of the techniques used to represent reality. Silveira makes parodic use of perspective — a system that should guarantee an exact representation — making visible what Leonardo referred to as "marginal aberrations of perspective" — that is, the distortions that appear in the process of projection by a supposedly exact geometric method. She also makes reference to the anamorphic system of geometric deformation to produce enigmatic images, which was first used in the sixteenth century.[27] For example, Silveira's series *In Absentia,* 1983, features enormous painted or cutout representations of shadows that appear strange to the untrained eye but, to anyone well versed in the history of art, are easily recognizable as allusions to Marcel Duchamp's *Bottle Rack,* 1914, and *Bicycle Wheel,* 1913.[28] The "shadow" in each work in the series originates from a three-dimensional pedestal and extends across the floor and the adjacent wall, effectively occupying the space with its presence. But the pedestals are empty; the referent exists only in the mind of the spectator, who, as we said before, arrives with mental baggage that allows him or her to interpret the forms of the absent objects as distorted representations of pre-existing art. "The eye accumulates

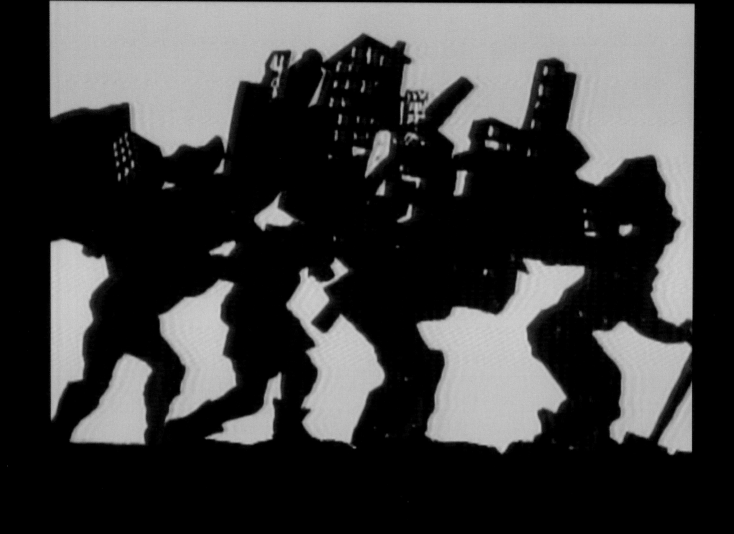

above and opposite: WILLIAM KENTRIDGE,
Shadow Procession, 1999 (video stills)

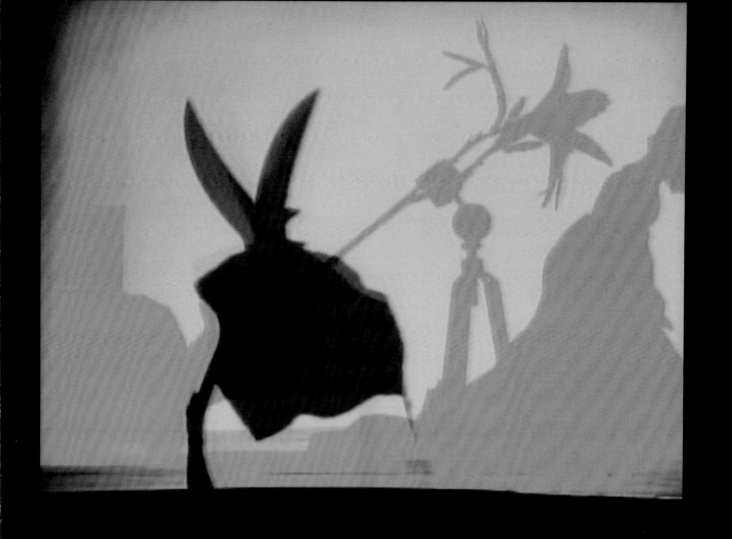

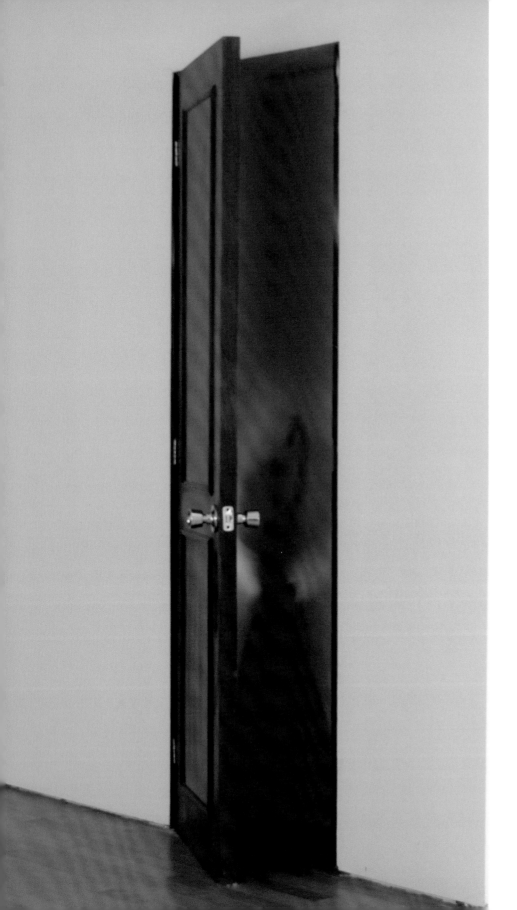

left and opposite: CHRISTIAN BOLTANSKI, *La Danseuse*
(*The Dancer*), 1987; installation view at Museo
de Arte del Banco de la República, Bogotá,
Colombia, 2007

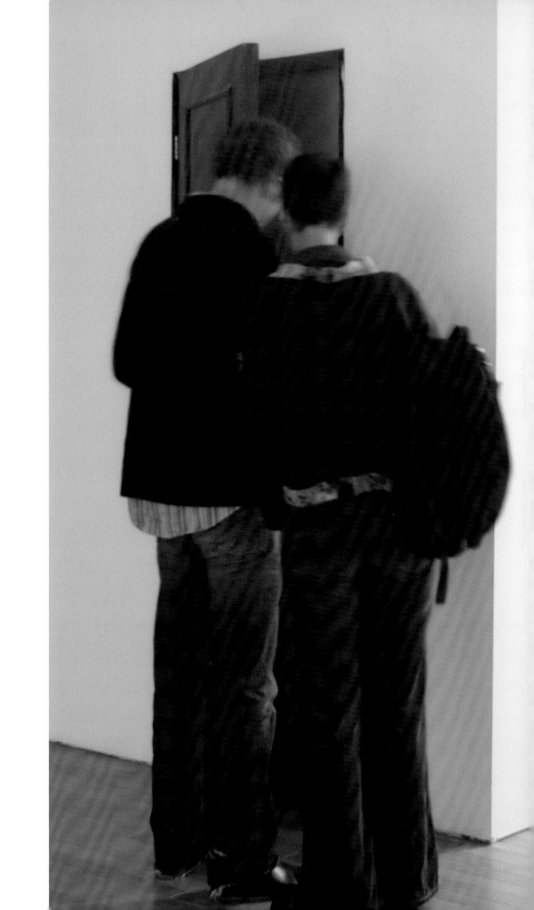

perspectives," Silveira stated on one occasion, referring to our capacity to restructure reality on the basis of diverse and often incongruent fragments. Her immobile shadows, with their multiple vanishing points or their variations and deformations in the rational process of perspective projection, deny the possibility of an objective point of view; as a result, the movement of the viewer establishes a completely different reading depending on his or her position with respect to the image. For Silveira, the rational urge to apprehend reality through classical systems of representation coincides with a surrealist impulse, resulting, perhaps, from her training with the artist Iberé Camargo, who was a student of Giorgio de Chirico. Through the deformation of the Renaissance projection technique, Silveira breaks down the indexical relationship that exists between an object and its shadow, between the shadow and the object that produces it. In the words of critic Justo Pastor Mellado,

> From this position, any attempt to project the amplification of everyday objects, furniture, or bodies implies an emphasis on the value of the surface of inscription as well as the distance between simulacra and their original forms: the anamorphic projection of shadows and objects onto other objects with which they have no homological relationship creates an intriguing dialog[ue] with surrealism and with their estrangement from the everyday appearance of things.[29]

Silveira's *Transitorio/Durevole* (*Transitory/Lasting*), 1997,* is also a game of visual contradictions. The work consists of a "shadow" of a woman reading made out of black plotter-cut vinyl that appears to be projected onto the floor and the wall, but the body that seems to have produced it is absent, although the "shadow" holds an actual book. The shadow is in reality that of Italian poet Mirella Bentivoglio, with whom Silveira, a Brazilian, created this collaborative work.

Like Silveira, Danish artist Julie Nord creates works with paradoxical shadows that don't correspond to their referent, and that often contradict it. Nord has interpreted classics of children's literature, such as Lewis Carroll's novel *Alice's Adventures in Wonderland* (1865), and has produced a series of drawings based on her personal vision of these stories, frequently using the aesthetics of Victorian illustration. *Alice's Adventures in Wonderland* is an interesting subject, since the story makes a clear allusion to a parallel universe and to an underground world, a subconscious realm where reality is distorted and where the laws of rational logic don't apply. In *The Hands,* 2007,* a large mural drawing done in black paint marker and water-based paint, Nord recalls the hand shadows that adults have traditionally devised to amuse children. *The Hands* tells a story in which the

shadows become progressively more independent of the hands that produce them, finally taking on a life of their own. The work evokes children's nightmares and the apprehension commonly felt by young children about the dark, causing their impressionable minds to interpret as monsters the ordinary shadows projected by everyday objects. As Danish critic Rune Gade has observed,

> the grotesque and the decorative are facets of Nord's drawings which mitigate the harshness of their subject matter, rendering these fairy tales for adults at a single stroke diverting, morbid and macabre. But most crucially: the pervasive innocence that is evoked does not eliminate the capacity to enthrall. As languid as things look in the drawings, so also do they strike the viewer as deeply intriguing They are pictures that reveal themselves to us as we see and re-see them: first as surfaces that hold us fascinated in their thrall, subjecting us to their logic; but then, as generous apertures that allow us to trace our own paths into new uncharted territories.[30]

Jim Campbell, trained as a mathematician and an electrical engineer, began creating interactive works in video and with electronic components during the late 1980s. He explores the limits of legibility by using electronic systems in which the image is reduced to its most basic elements, demonstrating that the eye and the brain tend to complete the missing information. Campbell's *Library, 2004,** is a photogravure that hangs on the wall like a picture, making reference to the illusionist space of Renaissance art, but activated by light. This work combines low-resolution electronic images with high-resolution photography, and fixed images with moving images. It consists of an image of the entrance of the New York Public Library superimposed on a grid of light-emitting diodes (L.E.D.'s). Campbell spent an entire day videotaping this crowded public space, and digitally condensed the visual information. He later transferred the data to a system of low-resolution L.E.D.'s so that only the minimum information necessary to maintain the illusion of coherent form and movement remained:

> Very low-resolution images exist at the borderline of abstraction. By reducing or eliminating the digital structure of an image, viewers are forced to search elsewhere in the image for meaning, causing color, motion and form to take on a new, more interdependent relationship with the interpretation of the image. In these works, as in other forms of visual abstraction, associative thinking processes play a larger role than linear or narrative thinking in the interpretation of an image. Understanding and using the characteristics of this process within an artistic methodology allows for unique forms of artistic expression while using only minute amounts of information.[31]

REGINA SILVEIRA, *Transitorio/Durevole*
(*Transitory / Lasting*), 1997; work made in
collaboration with Mirella Bentivoglio; installation
view at Museo de Arte del Banco de la República,
Bogotá, Colombia, 2007

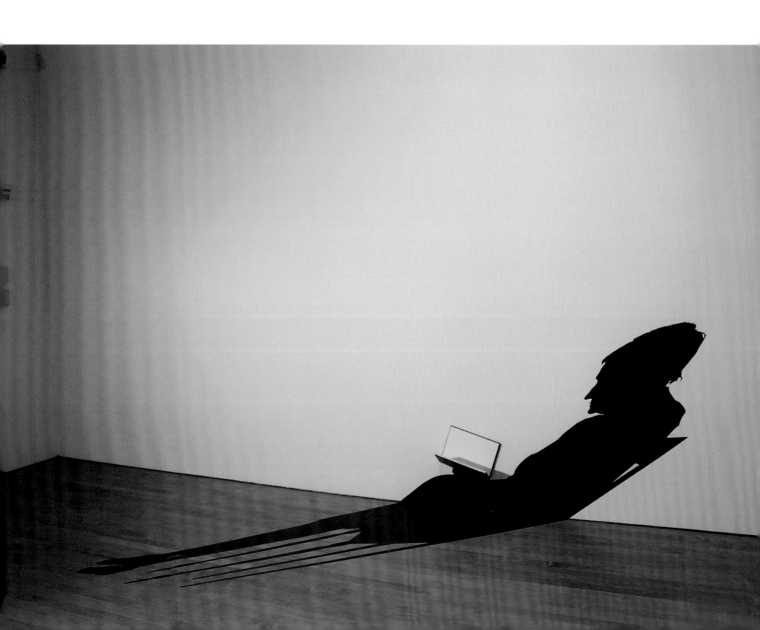

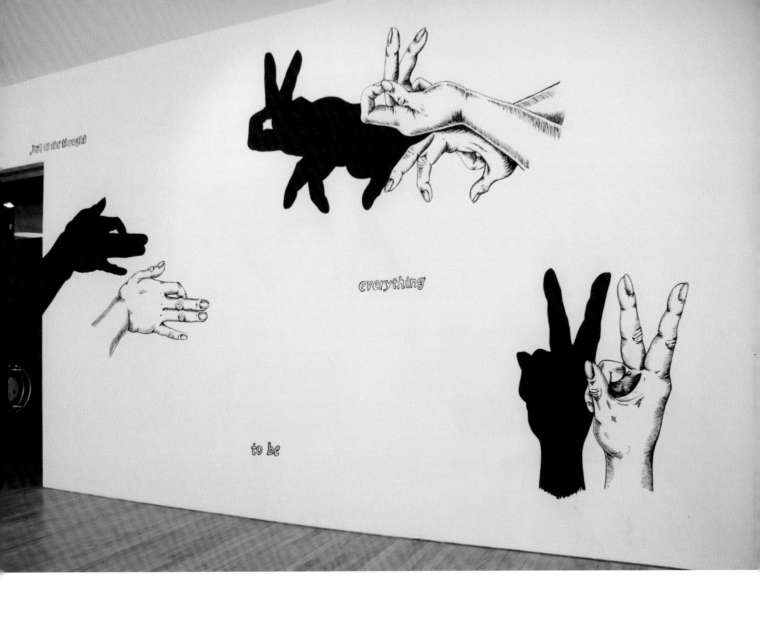

JULIE NORD, *The Hands*, 2007; installation view at
Museo de Arte del Banco de la República, Bogotá,
Colombia, 2007

Just as she thought

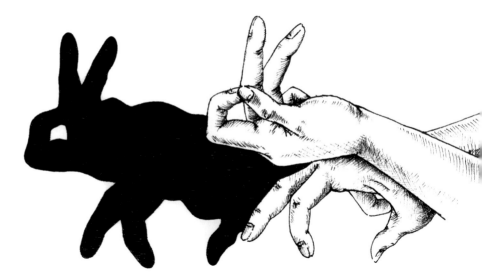

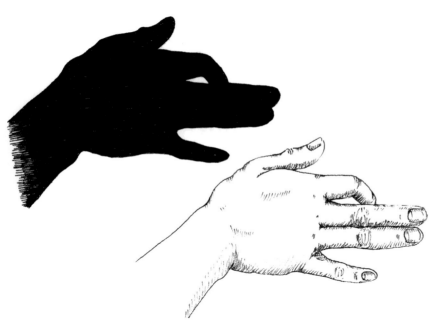

everything to be

in place...

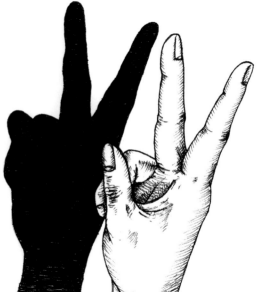

below and opposite: JULIE NORD, *The Hands*, 2007
(detail of installation)

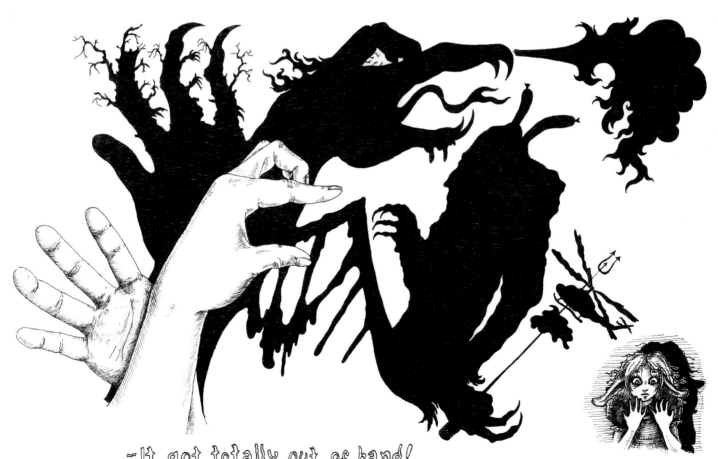

−It got totally out of hand!

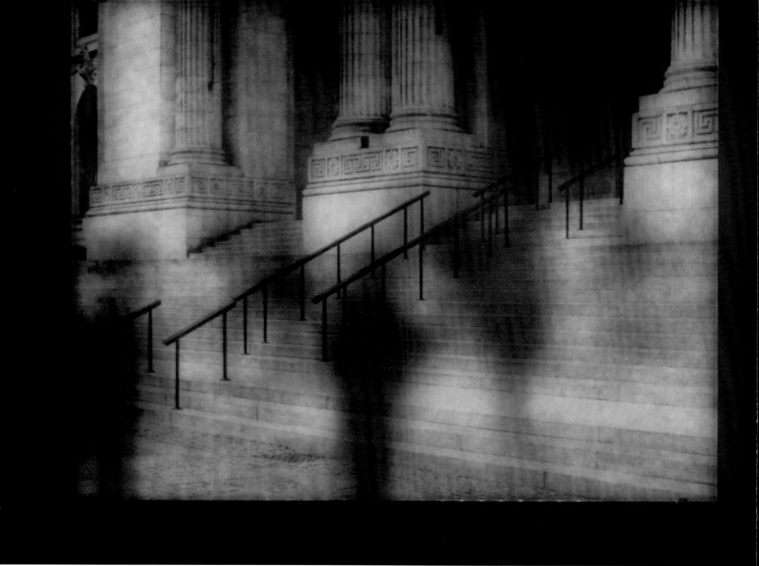

above and opposite: JIM CAMPBELL, *Library*, 2004

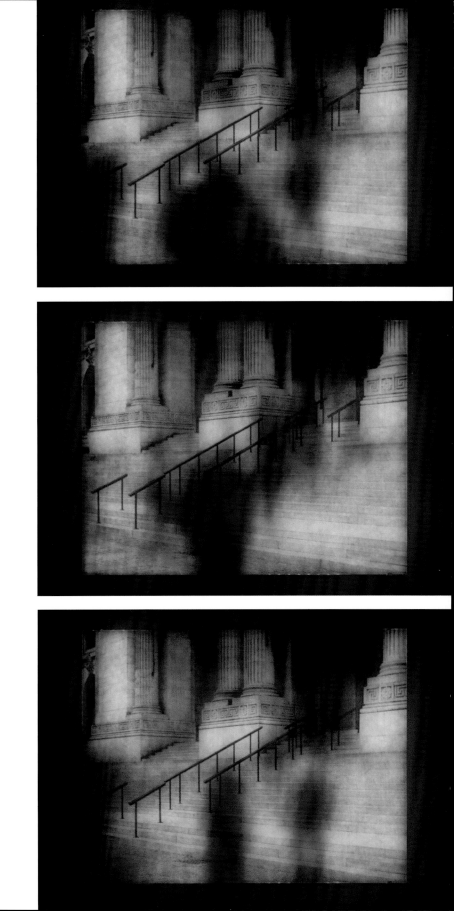

The image shows the steps and entrance to this neoclassical building, which underscores the reference to the classical orders of architecture based on rational principles. But a series of movements, of subtle presences, alter the static quality of the image. Are they shadows, or the ghostly presence of spirits that haunt the cold architectural setting? These presences have been the object of speculation: "The immutable columns and stones of the library are inhabited by floating chimera, translucent gray wisps traveling across the sidewalk and up and down the stairs. They are like the souls of all the people who ever moved through the time coordinate on the library's space-time axis."[32]

Riffing on the phantasmagoric references of the exhibition and subtly invoking the phantasmagoria shows, Rafael Lozano-Hemmer's interactive piece *Sustained Coincidence* (*Subsculpture 8*), 2007,* engages viewers in an active role of constructing an image by their active movement through space, using contemporary means of illusion. Earlier, Lozano-Hemmer had been making relational works where the viewer interacts with a light source to produce shadows on a surface, such as *Body Movies*, 2001, which drew its inspiration from van Hoogstraten's 1675 engraving. *Body Movies* consists of a series of photographs of passersby taken in various cities around the world, projected onto a large screen at the same time that powerful floodlights are directed at it, making the images temporarily invisible by "whitening out" the screen; the images become visible only when people stand in front of the screen and create shadows that block the floodlights and reveal a portion of the screen, shaped like their own body, while the rest of it stays white. The presence of these viewers and the blocking of light by their shadows reveal the "missing" bodies of anonymous people, constructing a relationship between the viewers and the unknown others. *Sustained Coincidence*, which Lozano-Hemmer created especially for this exhibition, works on a different level of interaction with the shadow, as he has explained. The complex installation consists of

> twenty incandescent bulbs [that] hang from the ceiling one meter above floor level, in a ten-meter line. If the room is empty there is darkness, except that all the lights are turned on very dimly so that only the glowing filaments can be seen. A computerized surveillance system observes the public and controls the lights automatically. When there is only one person in the room, the bulbs light up in synchronicity with his/her displacement, so that the shadow is always projected in the center of the opposing wall. When there are many people in the room, more bulbs light up so that every person has at least one shadow in the center of the wall, the place where all shadows overlap and thus exists a complete and collective obscurity.[33]

When experienced individually, the installation has a cinematic quality, as if strobe lights were marking the passage of the body through space. But when one enters the work in the presence of others, a different kind of relation with our dark "double" occurs: The shadow becomes a collective experience, as the device concentrates all absences (of light) in a central, composite form made from the juxtaposition of all the different shadows. *Sustained Coincidence* subsumes individual features into a single black void, where the trace of one's own body is consumed by total darkness.

In a world of omnipresent media images and a visually saturated society in which technology has demystified our relationship with images, the works presented in this exhibition might seem anachronistic in their attempts to restore an atavistic mystery, a lost enchantment, to the images of art. At a time when virtual reality has ceased to be an oxymoron and refers to a concept that is now fully integrated into the modern consciousness, there no longer seems to be a need for images that "haunt" us. Nevertheless, the fundamental existential questions have not changed: Who are we? Where do we come from? What will become of us when we're no longer here? The consciousness of death and of what happens beyond the grave continues to be a mystery that is equally compelling for mystics and agnostics, believers and atheists. Art is capable of presenting death (as in photography or in a documentary video), or of representing it through iconic images that societies have developed to express it. The references to the phantasmagoria tradition and to the shadow theater in some of the works that make up this exhibition are not the result of a romantic impulse to recover a lost tradition; rather, they reflect a vital interest in restoring the power of the image by evoking the memories of the mysterious that are in each one of us.

— Translation by Alex Ross

above and opposite: RAFAEL LOZANO-HEMMER,
Sustained Coincidence (*Subsculpture 8*), 2007;
installation view at Museo de Arte del Banco de
la República, Bogotá, Colombia, 2007

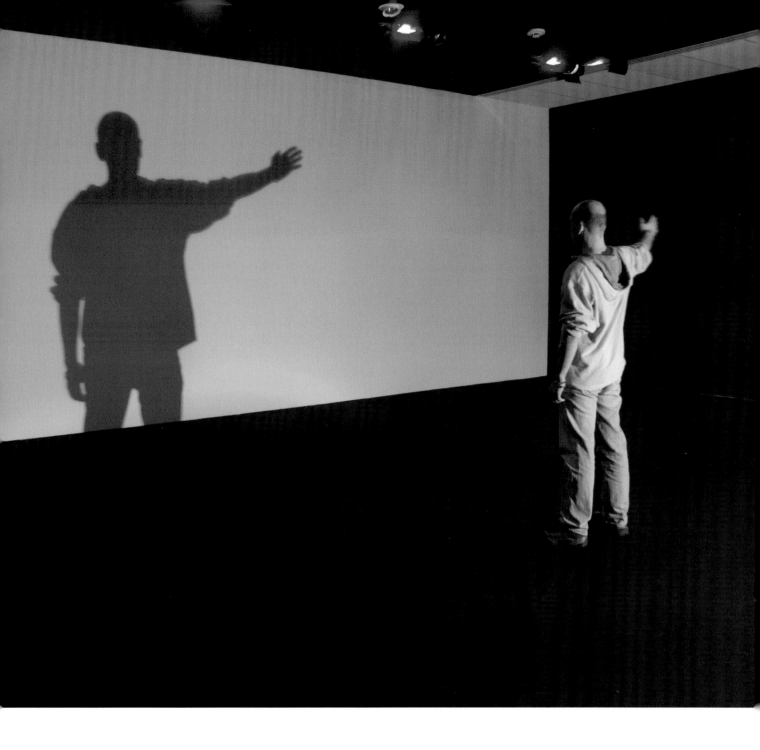

notes

1. Robert, Etienne-Gaspard (a.k.a. Robertson), quoted from "Robertson's Phantasmagoria," in Russell Naughton, "Adventures in Cybersound," 1998, on the Web page http://www.acmi.net.au/AIC/PHANTASMAGORIE.html, accessed in August 2006.

2. A term meaning "a display of optical effects and illusions" (literally "a gathering of ghosts"), derived from the French word *fantasme* and the Greek word *agora* ("assembly").

3. The success of phantasmagoria spectacles in England was undoubtedly motivated by the popularity of the Gothic novel, very prominent in English society at that time.

4. "The magic lantern, which is now the amusement only of servant-maids, and boys at school in their holidays, served at this remote period, and when the power of optical delusions was unknown, to terrify men of wisdom and penetration, and make them believe that legions of devils from the infernal regions were come among them, to produce the most horrible effects, and suspend and invert the laws of nature." William Godwin, *Lives of the Necromancers: or, an Account of the Most Eminent Persons in Successive Ages, Who Have Claimed for Themselves, or to Whom Has Been Imputed by Others, the Exercise of Magical Power* (London: Frederick J. Mason, 1834), p. 209.

5. In its most complex version, Robertson staged his spectacle in Paris in an abandoned Capuchin convent, close to the place Vendôme, where the audience arrived after crossing the graves.

6. The glass harmonica, invented in 1761 by Benjamin Franklin, consists of a series of glass bowls or wineglasses, graduated in size, that produce musical sounds when their surfaces are rubbed by moistened fingers. Robertson's choice of the glass harmonica was more than merely aesthetic, as it allegedly caused a physical and psychological effect: according to Tom Gunning, "the glass harmonica produced a music that seemed to many ethereal, possibly angelic. However, music historians commonly attribute the instrument's gradual loss of popularity to claims that its tones adversely affected the nerves, causing mental deterioration and other severe health problems." Tom Gunning, *Illusions Past and Future: The Phantasmagoria and Its Specters* (University of Chicago, 2005), p. 3, on the Web page http://www.mediaarthistory.org/Programmatic%20key%20texts/pdfs/Gunning.pdf, accessed in August 2006.

7. American scholar Diane Hoeveler has written, "As attendance at theaters increased throughout the nineteenth century, the technologies involved in stagecraft had to improve, and advancements in lighting, stage machinery, setting, and sound effects were all of major importance in the spectacularization of theatrical fare." Diane Long Hoeveler, "Smoke and Mirrors: Internalizing the Magic Lantern Show in *Villette*," in Robert Miles, ed., *Gothic Technologies: Visuality in the Romantic Era*, published December 2005 on the Web site "Romantic Circles Praxis Series" (University of Maryland), Praxis Series ed. Orrin N. C. Wang, http://www.rc.umd.edu/praxis/gothic/hoeveler/hoeveler.html, paragraph 3, accessed in May 2006.

 For a historical overview of phantasmagoria and the magic lantern, see Mervyn Heard, *Phantasmagoria: The Secret Life of the Magic Lantern* (London: Stephen Herbert, 2006); Terry Castle, *The Female Thermometer: Eighteenth-Century Culture and the Invention of the Uncanny* (New York: Oxford University Press, 1995); and Marina Warner, *Phantasmagoria: Spirit Visions, Metaphors, and Media into the Twenty-first Century* (New York: Oxford University Press, 2006).

8. Also notable were Paul de Philipsthal's *Phantasmagoria*, François Seraphin's *Ombres Chinoises*, Abbé Guyot's *smoke apparitions*, Mark Lonsdale's *Spectrographia*; Meeson's *Phantasmagoria*; the *Optical Eidothaumata*; the *Capnophoric Phantoms*; Moritz's *Phantasmagoria*; Jack Bologna's *Phantoscopia*; Schirmer and Scholl's *Ergascopia*; De Berar's *Optikali Illusio*; Sir David Brewster's *Catadioptrical Phantasmagoria*, Messter's *Kinoplastikon*, Henry Freeman-Biddall's *Phantospectraghostodrama*, Henri Rivière's *Théâtre d'Ombres* and John Henry Pepper's *Pepper's Ghost* (list based on Bruce Sterling's Dead Media Project Working Notes at http://www.deadmedia.org/notes/index-numeric.html, especially http://www.deadmedia.org/notes/15/152.html), accessed in December 2006.

9. "Ancient superstition would be eradicated when everyone realized that so-called apparitions were in fact only optical illusions. The early magic-lantern shows developed as mock exercises in scientific demystification." Castle, *Female Thermometer* (see n. 7, above), p. 143.

10. phantasmagoria: "a constantly shifting complex succession of things seen or imagined," as defined in Merriam Webster's online dictionary at http://www.merriam-webster.com/dictionary/phantasmagoria.

11. Martha B. Helfer, *Rereading Romanticism* (Amsterdam and Atlanta: Rodopi, 2000), p. 383.

12. Gunning, *Illusions Past and Future* (see n. 6, above), p. 7.

13. Castle, *The Female Thermometer* (see n. 7, above), p. 144.

14. http://www.wordinfo.info.

15. Steve Pile, *Real Cities: Modernity, Space and the Phantasmagorias of City Life.* (London: Sage, 2005), p. 20.

16. From a questionnaire sent all over the British Empire by the Victorian anthropologist James Frazer, who was making an inquiry into "the Customs, Beliefs, and Languages of Savages."

17. Nadine Guérin, interview with Michel Delacroix, 2002, on the Web page http://www.mdlx.com/pages/cv-textes.html#nadine, accessed in October 2006 (translated by the author).

18. Francesco Bonami, "Don't look! Move! – The work of Jeppe Hein in 1000 words," in Jeppe Hein, ed., *Jeppe Hein: Until Now* (London: Koenig Books, 2006), p. 4.

19. Some observers have compared the image with images of the cloud of dust and debris that filled the streets of New York when the Twin Towers of the World Trade Center fell on 9/11.

20. Mariano Navarro, quoted in Pat Binder and Gerhard Haupt, report on the 50th Venice *Biennale* in *Universes in Universe — Worlds of Art* (2003), on the Web page http://universes-in-universe.de/car/venezia/bien50/bra/e-renno.htm, accessed in December 2006.

21. Michel Leiris, journal entry, October 16, 1924, in Michel Leiris, *Journal 1922–1989*, ed. Jean Jamin (Paris: Gallimard, 1992).

22. In French, the term used for shadow theater is *ombres chinoises*, or "Chinese shadows."

23. Katrin Bettina Müller, "Inconstant Memory," on the Web page http://www.culturebase.net/artist.php?34, accessed in August 2006.

24. William Kentridge, quoted on the Web page about Kentridge at the 10th *Biennale de l'Image en Mouvement* (Biennial of the Moving Image), Saint-Gervais Genève (2003), http://www.10bim.ch/02prog/bim/bim10/retrospectives.php?id=id=r04&lg=en, accessed in December 2006.

25. Christian Boltanski, *Christian Boltanski: Inventar,* ed. Uwe M. Schneede (Hamburg: Hamburger Kunsthalle, 1991), pp. 73–75, quoted in Victor Stoichita, *A Short History of the Shadow* (London: Reaktion Books, 1997), pp. 200–201.

26. Ibid.

27. Perhaps the most famous anamorphic image is in the painting *The Ambassadors* (1533) by Hans Holbein the Younger (National Gallery, London), where the presence of a skull — one of the most frequent motifs of the phantasmagoria — is used as a *vanitas* to symbolize the transience of earthly existence.

28. Silveira has also created anamorphic versions of *Gift* (1921) by Man Ray and of *Object (Fur Lined Cup)* (1936) by Meret Oppenheim.

29. Justo Pastor Mellado, "The Pleasure of the Simulacrum," in *Arte e artistas plásticos no Brasil 2000,* ed. Ronaldo Graça Couto (São Paulo: Metalivros, 2000). p. 178.

30. Rune Gade, "Hybrid Pictures: On Julie Nord's Drawings," translated by Susan Dew (2003), on the Web page of the Mogadishni gallery (Copenhagen), http://www.mogadishni.com/site/artist.php?id=9, accessed in September 2006.

31. Jim Campbell, artist's statement for the exhibition *Surface Tension*, at the Fabric Workshop, Philadelphia (2003), on the Web page http://www.fabricworkshop.org/exhibitions/surface/campbell-statement.php, accessed in December 2006.

32. Michael S. Gant, "Focus Factors: Artists Jim Campbell and Misch Kohn Call for Close Regard," in the March 24–31, 2004 issue of *Metro*, on the Web page http://www.metroactive.com/papers/metro/03.24.04/campbell-0413.html, accessed in December 2006.

33. Lozano-Hemmer, e-mail to the author, March 2007.

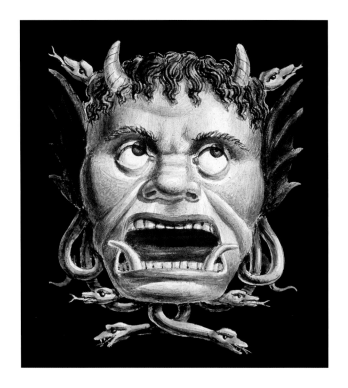

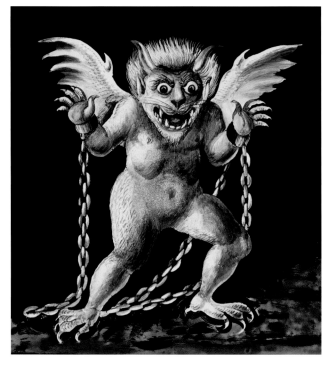

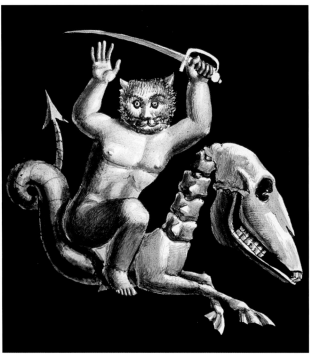

the phantoms of the colosseum

BRUCE STERLING

"WE HAVE A STORY MINUTELY RELATED BY BENVENUTO CELLINI IN HIS *LIFE*, WHICH IT IS NOW KNOWN WAS PRODUCED BY OPTICAL DELUSION, BUT WHICH WAS IMPOSED UPON THE ARTIST AND HIS COMPANIONS AS ALTOGETHER SUPERNATURAL. IT OCCURRED A VERY SHORT TIME BEFORE THE DEATH OF POPE CLEMENT THE SEVENTH IN 1534, AND IS THUS DETAILED. IT TOOK PLACE IN THE COLISEUM AT ROME."

—WILLIAM GODWIN, *LIVES OF THE NECROMANCERS* (1834)

"Only fools turn lead into gold," the wizard told Vincenzio. "To turn smoke into gold—that is a task for great adepts!"

Vincenzio methodically stripped a dead pigeon. The Roman Colosseum, like every ruin in Rome, was much haunted with pigeons. Vincenzio had a fine fowling piece: a loan from Benvenuto Cellini, the widely famed goldsmith and sniper. As the sun had set, Vincenzio had bagged six fat pigeons with as many shots.

So they would eat well tonight, thanks to him. The wizard never thought to bring any food when he raised devils.

The night was appropriately moonless and sinister. Red charcoal glowed in a squat three-legged tripod. The wizard's magic brazier featured curled bronze horns and legs like goats'.

The Colosseum was a wilderness of crumbling, columnar brick: one vast, weedy, reeking marsh. Its potholed arena brimmed over with phantoms and pestilential malaria. After dark, the Colosseum, true to its nature, became a Roman killing ground for bandits, mercenaries, and duelists. When the soldiers in the pope's merciless Swiss Guard came stamping into the place with their swords and halberds, they were by far the worst of the lot, for they were bandits, mercenaries, and duelists in their own right.

Phantasmagoria glass slides (clockwise from top left): *Medusa Head with Snakes; Diable* (Devil); *White Bearded Skull; Devil Riding Skeleton Horse*

{ 51 }

For this night's diabolical adventure, Vincenzio had thoughtfully brought along a heavy shirt of iron chain mail, his gun, black powder, twenty lead bullets, a loaf of dark flatbread, cheap red wine, two stout daggers, blankets, linen bandages, a Latin Bible, a sandalwood rosary, torches, hemp rope, charcoal, and a jug of holy water. The wizard, an owlish, bookish man, brought only his magic. He never thought these ventures fully through.

Blowing bloody pigeon feathers from his fingers, Vincenzio poured olive oil into an iron pan. He set the pan across the diabolical brazier. "So, master, now I smell some fine smoke! When do we get our gold?"

"Patience," smiled the wizard. "Devils work in mysterious ways."

"Aren't you hungry yet, sir?"

"The true adept of the Phantasmagoria hungers only for knowledge!" said the wizard. But he sniffed eagerly at the birds in Vincenzio's bubbling pan. The wizard was dressed as a Vatican cleric. But he had cautiously revealed his truer, darker nature to Vincenzio.

Vincenzio had been a hungry peasant, and an unhappy soldier. Nowadays he was a wizard's personal henchman. Vincenzio knew that his Phantasmagoric master was a heretic, a poisoner, an alchemist, a swindler, and a necromancer. Nevertheless, he was the best master Vincenzio had ever had.

The wizard could raise demons from hell. Vincenzio had seen that feat done: done here, right inside the ancient Colosseum. The wizard's awesome orgy of demonic conjuration had happened in front of four witnesses, one of those men being Benvenuto Cellini. As the pope's favorite goldsmith, Cellini was a very influential man in Rome. A rich man. A gifted man. A great man. A gullible man.

The six plucked pigeons sizzled merrily in Vincenzio's big smoking pan. The wizard declared: "To reveal the mystic workings of the Phantasmagoria is a solemn business. But you, Vincenzio Romoli: with your steadfastness and loyalty to me: you have proved yourself worthy."

Vincenzio took a pigeon from the pan and set it on a slice of black bread. "Your Worship, your nobility touches my heart! I ask nothing better of life than to serve you faithfully! How about a little wine to go with that fine bird, sir? It's Piedmontese Barbera!"

After sucking clean the bones of two pigeons, the wizard mysteriously vanished into the shadows, as was his habit. Vincenzio minded the cooking. The wizard presently returned. He was lugging his Magic Spirit Box.

"Where did you hide that, sir?"

"Never you mind where I hide it," said the wizard, panting and knocking fresh mud from his sandals. "There are a million hiding-holes in this rotten old Colosseum. This is where Cellini hid all those jewels that he stole from the pope."

Vincenzio said nothing about that issue. The wizard had ordered him to befriend Cellini. Vincenzio had obeyed, so he had come to know Cellini well. The dashing goldsmith was a terrifying swordsman and a master of artillery, but Benvenuto Cellini would never rob a pope. Especially not a Medici pope from Florence, his hometown.

Besides, the pope's jewels couldn't possibly be hidden in the Colosseum. Ever since the brutal Sack of Rome in 1527, Pope Clement had had a thousand woes to complain about, but he'd never mentioned missing the papal jewels.

Using his Phantasmagoria, the wizard had been stalking Cellini for months. He'd woven a web of smoky deception around the pope's goldsmith. The wizard had bribed Cellini's mistress and suborned his apprentices—all in a grand scheme to enrich himself with a pope's imaginary treasures.

They ate the last pigeons and finished the black bread. Then the wizard reached within his velvet cloak. He removed a mystical moleskin pouch, opened it, and cast its contents into the brazier. It seemed no more than sandy bits of gum, but it produced a raging, roiling, almighty column of smoke.

Then the wizard invoked his Magic Spirit Box. This was an awesome device, its corners bound in brass and silver, the black wood inscribed in Greek, Hebrew, and Arabic. The wizard inserted a glowing chunk of phosphorus into an iron tong within it. Then he seized a hotly glowing coal straight from the brazier, and touched off the Magic Box like a cannoneer. The Box gushed a blinding beam of light. The beam leaped through a black nozzle with a thick disk of clear glass. It danced across the eerie columns of the Colosseum.

"Point it downward," hissed the wizard, "someone might see." He produced a frail rectangle of glass, carefully wrapped in thick parchment. "My boy, I must now introduce you to a great eminence! Asmodeus, Satanic Duke of a Host of Demons!"

Vincenzio watched as the wizard slid this painted glass into a copper slot in the Box. It was Venetian glass, with a wash of color, much like stained-glass pictures in the windows of a church. The great demon lord Asmodeus capered across the glass in small colored cartoons, with two little legs and littler arms. He had a long barbed tail.

"Master, I know this demon Asmodeus," said Vincenzio. "Two nights ago, I saw him dancing here in midair, as big as a house. Cellini saw the devil, too. And Cellini was drunk with fear."

"Do you know what opium is?"

"Yes, I do. It's a deadly poison. Ten grains of opium will kill a man."

The wizard tucked one black opium pellet between his cheek and jaw. He sucked on it with relief, for his teeth were bad, and they always pained him. "I also

burn much Ottoman hashish whenever I raise devils. So this brazier smells like a burning rope. Did you notice that? Like a hemp rope."

"I've never burned a hemp rope."

"But you saw Cellini and the friend he brought, that brash fool Gaddi. They both breathed the smoke. Then they saw devils dancing in that smoke. They drew their swords to fight the fiends from hell, howling and blaspheming . . . "

"Gaddi soiled his own pants," concurred Vincenzio. "That smelled even worse than burning rope."

"Such is the awesome power of Phantasmagoria! Completely bewitched, Cellini almost showed us where he hid the pope's gems!" The wizard licked his bearded lips. "I promised him that his absent mistress, the courtesan Angelica, will return soon to his arms. Between that woman's wicked skills and my Phantasmagoric sorcery, the lost treasure of Christ's Vicar is as good as ours!"

"Master, the dark secrets of your craft are truly sublime."

"They are. And now we rouse a demon from hell," said the wizard. "This time, you can do it. Slide this painted glass before the fire in the Box."

Vincenzio followed these instructions with care. The painted cartoon shot from the Box and struck the billowing smoke from the mystical brazier. As thick fumes rose and gushed and curdled in midair, the image kicked and grimaced. Vincenzio moved the glass slide, changing the cartoons. The effect was even more astounding.

Yes, this simply had to be the greatest magic in the entire world. There was no other enchantment fit to match this. The pope himself would believe in risen devils, if he saw these fiery phantoms. The Holy Roman Emperor, too, or the King of France, or the Sultan of the Turks, or the Khan of China. Anyone. Anyone in the world.

Lifting the heavy Box, and sniffling over its fumes, Vincenzio aimed the colored beam around the Colosseum. The demon rose and rippled across the ancient stones and bricks—faintly, distantly, eerily.

This Colosseum was a long-dead place, but Vincenzio knew, from those many stairs and stony pews, that thousands of people had come here once. They had flocked inside the Colosseum to see amazing marvels.

Mankind had forgotten so many great things. Wonderful things were so very easy for people to forget.

The hot fire in the Box guttered out with a sulfurous stink.

"Never flash the light around like that. It's too risky."

"Sorry, master. I'm still trying to understand."

"You yourself will use this Magic Spirit Box, next time that I raise devils for the goldsmith of the pope. As a further refinement, you will also beat large sheets

of iron with a hammer, which will make a huge demonic noise. Also—hidden in darkness—you will howl like the creatures from hell. Can you do all that, good Vincenzio?"

Vincenzio set the heavy box against the earth, with tender care. "Yes, I can do all that, master! Voilà, presto, abracadabra! The great trick is light and glass and painted pictures!"

"No, the truly great trick is to use that Box to make me, your master, as rich as the pope."

"Master, tell me something. Why are we showing our wonderful Phantasmagoria to just one man?"

"Because Cellini knows the pope!"

"But master, I see this huge Colosseum all about us," said Vincenzio, "and I wonder, in my mind: what if we filled this Colosseum with the people of Rome, and we showed them all our fiery Phantasmagoria? Wouldn't that be very bold and glorious of us?"

"What? We can't defile every soul in Rome with our necromantic diabolism! Even a Borgia would flinch!"

"But master! Suppose that we draw new pictures on these slides of glass: beautiful pictures. Happy things that people love to see! We could make people pay us to see those lights and shadows. Everyone would want to watch."

"We can't reveal the ancient arts of necromantic craft to mere peasants! Once you reveal a magic secret, it becomes worthless! You're learning, but you're not yet thinking like a necromancer." The wizard drew himself to his full height. "You can work the Phantasmagoria now: but you don't yet know how to build one!

"Maybe ten men in the world know that, and they are all sworn to secrecy. So: I am going to hide this precious Magic Spirit Box, in a place that only I know. We must part for now. Leave this evil place with care."

The wizard vanished into darkness. Vincenzio, with all due caution, skulked away through the ruins. An owl hooted. The summer night was damp and black.

As he worked his way toward a crumbling exit, he heard the heavy tramp of boots, the ring of martial metal. Torches glittered in the darkness. The Swiss Guards were cursing in German, for they were frightened half to death.

Vincenzio cast himself into the reeds and mud, and hid there still as death while mosquitoes feasted on his flesh.

Vincenzio never saw the wizard again. After weeks of determined searching in the Colosseum, growing lean and hungry and ragged, he found the Magic Spirit Box. It was blackened and broken.

Tramps had been using it for a stove.

artists' statements and biographical information

christian boltanski

BORN 1944, PARIS, FRANCE; LIVES IN PARIS

"I relate many things to shadows. First of all because they remind us of death (do we not have the expression 'shadowlands'?). And then, of course, there is the connection with photography. In Greek the word means writing with light. The shadow is therefore an early photograph. . . . It is this aspect of the shadow which intrigues me, for it is pure theatre in the way that it is an illusion. . . . What appeals to me so much about shadows is that they are ephemeral. They can disappear in a flash: as soon as the reflector is turned off or the candle extinguished there is nothing there any longer."

—Boltanski, quoted in Victor Stoichita, *A Short History of the Shadow* (London: Reaktion Books, 1997), pp. 200 – 201.

SELECTED SOLO EXHIBITIONS: *6 septembres,* Musée d'Art Moderne de la Ville de Paris/ARC and L'Institut National de l'Audiovisuel, Paris, 2005; *Théâtre d'ombres 1984 – 1997,* Musée d'Art Moderne de la Ville de Paris/ARC; Musée d'Art et d'Histoire du Judaïsme, Paris, 2004; *Christian Boltanski: Reflexion,* Museum of Fine Arts, Boston, 2000; Museum of Modern Art, Caracas, 1999; Biblioteca Luis Ángel Arango, Bogotá, 1999.

SELECTED GROUP EXHIBITIONS: *La Force de l'Art,* Grand Palais, Paris, 2006; *Correspondances,* Musée d'Orsay, Paris, 2005; *Eyes, Lies & Illusions,* Hayward Gallery, London, 2004; *The Disembodied Spirit,* (traveling exhibition: Bowdoin College, Maine; Kemper Museum of Contemporary Art, Kansas City, Missouri; Austin Museum of Art, 2003 – 4); *The Last Picture Show: Artists Using Photography, 1960 – 1982,* Walker Art Center, Minneapolis, and U.C.L.A. Hammer Museum, Los Angeles, 2003 – 4; Lyon *Biennale d'Art Contemporain,* 2003; *Face(t)s of Memory,* Jewish Museum, San Francisco, 2001 – 2; *Moving Pictures,* Solomon R. Guggenheim Museum, New York, 2002; *The Museum as Muse: Artists Reflect,* Museum of Modern Art, New York, 1998; *Do It* (iCI, traveled to 18 institutions, 1997 – 2001); Venice *Biennale,* 1995; *Burnt Whole: Contemporary Artists Reflect on the Holocaust,* Washington Project for the Arts, Washington, D.C., and Institute of Contemporary Art, Boston, 1994 – 95; Venice *Biennale,* 1993; *Carnegie International,* Carnegie Museum of Art, Pittsburgh, 1991; *Les Magiciens de la Terre,* Grande Halle de la Villette and Centre Georges Pompidou, Paris, 1989; *On the Art of Fixing a Shadow,* National Gallery of Art, Washington, D.C., and Art Institute of Chicago, 1989; São Paulo *Biennal,* 1983; Venice *Biennale,* 1980; *Documenta 6,* Kassel, Germany, 1977.

AWARDS: Kaiserrin der Stadt Goslar, 2001; Kunstpreis, given by Nord/LB, Braunschweig, Germany, 2001; Kunstpreis der Stadt Aachen, 1994.

JULIE NORD, *The Hands,* 2007
(detail of image on p. 40)

jim campbell

BORN 1956, CHICAGO, ILLINOIS; LIVES IN SAN FRANCISCO, CALIFORNIA

EDUCATION: S.B. DEGREE IN MATHEMATICS AND ENGINEERING, 1978, MASSACHUSETTS INSTITUTE OF TECHNOLOGY, CAMBRIDGE, MASSACHUSETTS

Does your work relate in a direct or indirect way to the historical Phantasmagoria shows, or with the tradition of the shadow theater? If so, how? If not, how does it reflect on absence, loss, or death?

"Whether the work relates or not to Phantasmagoria shows or shadow theater, I am afraid that I will leave you to answer if the work connects to these. I can say that neither of these past events directly inspired or influenced the creation of the work in a conscious way.

"[For my 2004 work *Library*,] I chose the library, with its classic old eternal architecture, to superimpose the moving images of the people who entered it on a certain day because I wanted to juxtapose the permanent with the fleeting, paralleling the mixing of the mediums which have the same permanent/fleeting dialogue going on (photography/electronic). And I specifically chose the library to represent the permanent because, with current information technology, I am one who believes that libraries will soon be a thing of the past. So the choosing of the New York Public Library as an unwavering icon of culture, looking back, was done in irony, as I see the library and the people visiting it that day as ghosts visiting a deserted building."

SELECTED SOLO EXHIBITIONS: *Quantizing Effects*, SITE Sante Fe, New Mexico, 2005; *Algorithmic Revolution*, ZKM, Karlsruhe, 2004; *Memory Array*, Berkeley Art Museum, California, 2003; *Data and Time*, Nagoya City Art Museum, Japan, 2002; *Time and Data*, Wood Street Galleries, Pittsburgh, 2001; *Reactive Works*, San Jose Museum of Art, California, and Art Center College of Design, Pasadena, California, 1997–98; *Digital Watch*, Kemper Museum of Contemporary Art, Kansas City, Missouri, 1997.

SELECTED GROUP EXHIBITIONS: *What Sound Does a Color Make?* (iCI, traveled to 6 institutions, 2005–7); *Surface Tension*, Fabric Museum, Philadelphia, 2005; *Walk Ways*, (iCI, traveled to 8 institutions, 2002–4); Taipei *Biennial*, Taiwan, 2002; *Whitney Biennial*, Whitney Museum of American Art, New York, 2002; Busan *Biennial*, South Korea; *Future Cinema*, ZKM, Karlsruhe, Germany, 2002; *Bitstreams*, Whitney Museum of American Art, New York, 2002; *Ars Electronica*, Linz, Austria, 2000; *Body Mecanique*, Wexner Art Center for the Arts, Columbus, Ohio, 1998; *Serious Games*, Barbican Art Gallery, London, 1998; *Creative Time: Art in the Anchorage*, Brooklyn, New York, 1996; *Iterations*, International Center of Photography, New York, 1993; *Facing the Finish*, San Francisco Museum of Modern Art, 1992.

PUBLIC ART: Phoenix, Arizona, 1992 (one of the first permanent public interactive video artworks in the U.S.); also Denver, Tampa, New York, Pittsburgh, and San Francisco.

AWARDS: Rockefeller Grant in Multimedia; Guggenheim Fellowship Award; Langlois Foundation Grant; Eureka Fellowship Award; two Honorable Mentions in Interactive Art at *Ars Electronica*, Linz, Austria.

michel delacroix

BORN 1955, SAINT-CLAUDE, FRANCE; LIVES IN CLAIRVAUX-LES-LACS, FRANCE
EDUCATION: STUDIED AT THE ECOLE NATIONALE SUPÉRIEURE DES ARTS APPLIQUÉS, PARIS

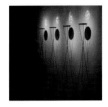

Does your work relate in a direct or indirect way to the historical Phantasmagoria shows, or with the tradition of the shadow theater? If so, how? If not, how does it reflect on absence, loss, or death?

"With regard to its form and the use of light and reflections, it seems evident that my work inscribes itself within the visual universe of the Phantasmagoria, but at the moment when I was creating this particular piece [*Lisetta, Ferdinand, Saverio, Edward*, 1995], I did not reflect upon this specific affiliation, nor did I deliberately choose to inscribe myself within this pictorial tradition.

"Nevertheless, the theme of the exhibition revealed to me many bonds and common concerns related to absence, loss, and disappearance that were in perfect resonance with the piece. Indeed, the work evokes the fragility of life; it tries to make visible what is immaterial, to capture what is impossible to grasp. It is also a questioning about perception, on how images appear and their interdependence with the gaze of the viewer.

"The device is ironic, because the more one approaches the work, the more the image escapes. This distance is necessary to neutralize the gravity of the questions that are called into play. This is a convergence that one finds regularly in the history of the Phantasmagoria."

SELECTED SOLO EXHIBITIONS: *Tamis du Temps*, Musée des Beaux-Arts, Lons-Le-Saunier, 2001; *Ouate Watt What*, Galerie Naktin-Berta, Paris, 1995.

SELECTED GROUP EXHIBITIONS: *Va&vient*, Musée des Beaux-Arts, Lons-Le-Saunier, France, 2007; IPL2006, Limoges, France, 2006; *Autour de Robert*, Traverse Vidéo festival, Toulouse, France, 2005; *Topilo Utopia*, Hajnowka, Poland, 2005; *Luxe de Luxe*, Avenue K, Kuala Lumpur, 2004; *Siméon* (with Pierre-Yves Freund), Traverse Vidéo festival, Toulouse, 2004; *Probablement*, Musée Cima, Saint Croix, 2003; *Bingo*, Galerie Thaddaeus Ropac, Paris, 2002; *On Ne Sait Jamais* (with Pierre-Yves Freund), Galerie Granit, Belfort, France, 2002; …*Qui nous noue — Un monde d'illusions*, Centre Culturel Aragon, Oyonnax, France, 2001; *Translacje*, Piotkrow Tribunalski, Poland, 1999; *Mortality Immortality? The Legacy of 20th-Century Art*, Getty Conservation Institute, Getty Center, Los Angeles, 1998; *Misteri della presenza*, Festival of the Two Worlds, Spoleto, Italy, 1997; *Sous le manteau*, Galerie Thaddaeus Ropac, Paris, 1997; *Encore un effort*, SAGA/FIAC and galerie Naktin-Berta, Paris, 1996; and *Hors d'œuvre*, Getty Conservation Institute, Getty Center, Los Angeles, 1995.

PUBLIC ART: *Anamorphoses*, for the Musée de la Lunetterie, Morez, France, 2004; *Aire de Garabit*, for the Conseil Général, Cantal, France, 2003; *Le Pavillon des Cercles* (*The Pavilion of Circles*), for the Conseil Général, Jura, France, 1999.

laurent grasso

BORN 1970, SAÂDANE AFIF, FRANCE; LIVES IN PARIS

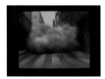

Does your work relate in a direct or indirect way to the historical Phantasmagoria shows, or with the tradition of the shadow theater? If so, how? If not, how does it reflect on absence, loss, or death?

"The Magic Lantern evokes for me a period when cinema was nothing more than a projection machine at its most elementary level. The technique was scarce, and the mental projection did the rest. In the different devices that I have put in place I tried to create a double projection. The images become surfaces of mental projection, the systems are open.

"I think of my installations as machines that project themselves on other realities. A little more technological then the ones on the 'phantasmagoria shows,' but of the same nature, of the same function. Throughout the technological evolution of photography, radio, and now electromagnetic waves, mythologies have arisen, such as (for photo and radio) the possibility of communicating with the dead, and today (with electromagnetic waves) to modify climate and thought from a distance. I thought it interesting to exploit in my work these potential functions as fictions.

"The cloud in my video *Projection* is a projection surface, a mental object that can absorb all interpretations and return its form modified by our desires or our fears. All our contemporary paranoia can crystallize on it without ever finding any answers."

SELECTED SOLO EXHIBITIONS: *Power Chords / 10 pièces réduites*, Fondation Prince-Pierre de Monaco, Monaco, 2006; *Lyrics*, Palais de Tokyo, Paris, 2005; *One Million BPM*, Cimaise et Portique, Albi, France, 2005; *OK / OKAY*, Swiss Institute, New York, 2005; *Melancholic Beat*, Museum Folkwang, Essen, Germany, 2004; *Radio Ghost*, CREDAC, Ivry-sur-Seine, France, 2004; *Memory Lost*, Villa Arson, Nice, 2003.

SELECTED GROUP EXHIBITIONS: *Notre Histoire*, Palais de Tokyo, Paris, 2006; *Midnight Walkers*, Kunsthaus Basel, Switzerland, and CREDAC, Ivry-sur-Seine, 2006; *Satellite of Love*, Witte de With, Rotterdam, 2006; *From There*, Bloomberg SPACE, London, 2006; Lyon *Biennale d'Art Contemporain*, 2005; Tirana *Biennale*, Albania, 2005; *Down at the Rock 'n Roll Club*, Moscow Art Biennial, 2005; *Vidéo Fresnoy, productions // Projections*, Jeu de Paume, Paris, 2005; *Playlist*, Palais de Tokyo, Paris, 2004; *One Minute Before*, Macao, China, 2003.

GROUP VIDEO PROGRAMS AND FILM FESTIVALS: *Loop* video art festival, Institut Français de Barcelone, Barcelona, 2005; *Nuit Blanche*, Cinéma l'Entrepôt, Paris, 2004; *Swiss American Film Festival*, Swiss Institute, New York, 2004; and *Artificial Beauty*, Art Film, Art Basel, 2003.

jeppe hein

BORN 1974, COPENHAGEN, DENMARK; LIVES IN COPENHAGEN AND BERLIN
EDUCATION: ROYAL DANISH ACADEMY OF ARTS, COPENHAGEN, 1997; STÄDEL
HOCHSCHULE FÜR BILDENDE KÜNSTE, FRANKFURT-AM-MAIN, 1999

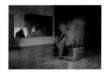

Does your work relate in a direct or indirect way to the historical Phantasmagoria shows, or with the tradition of the shadow theater? If so, how? If not, how does it reflect on absence, loss, or death?

"Although the use of smoke in my work reminds one of the eerie atmosphere of the historical Phantasmagoria shows and the shadow theater, it does not really relate to it. Nor does the *Smoking Bench* reflect on loss or death either, but it refers in a way on absence and presence, like many of my works.

"When visitors sit down on the small bench facing a large mirror, a cloud of smoke is released from the bench. While contemplating their reflection in the mirror, viewers see themselves disappear in a cloud of smoke which subsides after a short while, letting them reappear again. Instead of offering the viewers the possibility to be aware of their presence by seeing their image in the mirror, the work questions and somehow refuses their presence, and the viewers find themselves in a situation where they seem to be absent momentarily."

SELECTED SOLO EXHIBITIONS: *Illusion*, Sculpture Center, Long Island City, New York, 2007; The Contemporary Museum, Honolulu, 2007; *The Curve*, Barbican Art Gallery, London, 2007; Masami Shiraishi, Tokyo, 2007; *X-Rummet*, Statens Museum for Kunst, Copenhagen, 2006; *Invisible Labyrinth*, Espace 315, Centre Georges Pompidou, Paris, 2005; *Flying Cube*, P.S.1 Contemporary Art Center, New York, 2004; *Continuity Reflecting Space*, Fondación La Caixa, Barcelona, 2003.

SELECTED GROUP EXHIBITIONS: *The World as a Stage*, Tate Modern, London, 2007–8; *Made in Germany*, Sprengel Museum, Hannover, 2007; Schirn Kunsthalle, Frankfurt, 2006; Liverpool *Biennale*, 2006; *Le Mouvement des Images*, Centre Georges Pompidou, Paris, 2006; *Play Station*, Sprengel Museum, Hannover, 2006; *Black Market Worlds*, 9th Baltic Triennial of International Art, CAC Vilnius & ICA Vilnius, 2005; *Ecstasy: In and About Altered States*, Museum of Contemporary Art, Los Angeles, 2005; *Moving Parts*, Museum Tinguely, Basel, 2005; *Universal Experience: Art, Life, and the Tourist's Eye*, Museum of Contemporary Art, Chicago, 2005; *A Secret History of Clay: From Gauguin to Gormley*, Tate Liverpool, 2004; *Interludes*, Venice *Biennale*, 2003; *The Straight or Crooked Way*, Royal College of Art, London, 2003; *I Promise It Is Political*, Museum Ludwig, Cologne, 2002.

william kentridge

BORN 1955, JOHANNESBURG, SOUTH AFRICA; LIVES IN JOHANNESBURG
EDUCATION: B.A. IN POLITICS AND AFRICAN STUDIES, UNIVERSITY OF WITWATERSRAND,
1973—76; STUDIED ART AT JOHANNESBURG ART FOUNDATION, 1976—78; STUDIED MIME AND
THEATER AT ÉCOLE JACQUES LECOQ, PARIS, 1981—82

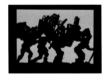

"Shadow is all appearance, immateriality, without substance; but at the same time gives a way of avoiding the seduction of surface—often referred to as appearance as opposed to essence. What are we doing with these simplified figures with reduced or non-existent inner lives? It does not help to think, 'this shadow figure was beaten when small.' One has to find the movement the figure suggests, and from this find its gestures, its meaning—that in the end may provoke recognition of a world not so far from the psychological space we would use if working in a naturalist manner. But here one arrives at this world as a discovery, not an assumed knowledge at the beginning of the performance. The second, harder point has to do with the critique of psychology as a way of understanding the world.

"Understanding that the blankness of the shadow, the lack of psychological depth, may be an asset—that understanding the world not through individual psychology is often appropriate and stronger.

" . . . And if there is one thing that art can make clear, it is to make us conscious of the precept 'Always be mediating.' All calls to certainty, whether of political jingoism or of objective knowledge, have an authoritarian origin relying on blindness and coercion—which are fundamentally inimical to what it is to be alive in the world with one's eyes open."

—From William Kentridge, "In Praise of Shadows" (lecture, Chicago, October 2001).

SELECTED SOLO EXHIBITIONS AND FILM RETROSPECTIVES: Miami Art Central, Miami, 2006; Johannesburg Art Gallery, Johannesburg, 2005; Metropolitan Museum of Art, New York, 2004; Baltic Art Center, Visby, Sweden, 2003; *Confessions*, Festival d'Automne de Paris, Centre Georges Pompidou, Paris, 2002; *William Kentridge Retrospective* (traveling exhibition: Hirshhorn Museum and Sculpture Garden, Washington, D.C.; New Museum of Contemporary Art, New York; Museum of Contemporary Art, Chicago; Contemporary Arts Museum, Houston; Los Angeles County Museum of Art, Los Angeles; and South African National Gallery, Cape Town, 2001–3); *Stereoscope*, Museum of Modern Art, New York, 1999; Drawing Center, New York, 1998.

SELECTED GROUP EXHIBITIONS: Venice *Biennale*, 2005; *Daumenkino: The Flip Book Show*, Kunsthalle Düsseldorf, 2005; *Take Two: Worlds and Views*, Museum of Modern Art, New York, 2005; *Africa Remix: Contemporary Art of a Continent* (traveling exhibition: Hayward Gallery, London; Centre Georges Pompidou, Paris; and Museum Kunst Palast, Düsseldorf, 2004–5); *Faces in the Crowd, Picturing Modern Life from Manet to Today*, Whitechapel, London, 2004; Auckland *Triennial*, 2004; *Moving Pictures*, Solomon R. Guggenheim Museum, New York, and Guggenheim Museum Bilbao, 2002–4; *Documenta 11*, Kassel, Germany, 2002; Havana *Bienal*, 2000; Shanghai *Biennial*, 2000; Kwangju *Biennial*, South Korea, 2000; Venice *Biennale*, 1999; Istanbul *Biennial*, 1999; *Carnegie International*, Carnegie Museum of Art, Pittsburgh, 1999; *Unfinished History*, Walker Art Center, Minneapolis, and Museum of Contemporary Art, Chicago, 1999; São Paulo *Bienal*, 1998; *Documenta 10*, Kassel, Germany, 1997; Havana *Bienal*, 1997; Johannesburg *Biennial*, 1997; Sydney *Biennial*, 1996; Johannesburg *Biennial*, 1995; Istanbul *Biennial*, 1995; Venice *Biennale*, 1993.

AWARDS: Rosenberger Medal, University of Chicago, 2006; Sharjah Biennial 6 Prize, 2003; Kaiserring Prize, Mönchehaus-Museum für Moderne Kunst, Goslar, 2003; Carnegie Prize, 2000; Blue Ribbon Award, American Film Festival, 1985.

rafael lozano-hemmer

BORN 1967, MEXICO CITY; LIVES IN MADRID AND MONTREAL
EDUCATION: B.SC. IN PHYSICAL CHEMISTRY, 1989, CONCORDIA UNIVERSITY, MONTREAL

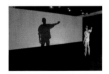

Does your work relate in a direct or indirect way to the historical Phantasmagoria shows, or with the tradition of the shadow theater? If so, how? If not, how does it reflect on absence, loss, or death?

"Yes it does. I think it is impossible to work with representation and not be influenced by these traditions, even if indirectly through their effect on Blake, Fuseli, or Goya, for example.

"Embracing the concept of 'special effects' is one key contribution from the Phantasmagoria masters like Robertson, who himself was a physicist and always boasted how his shows were the result of ingenious equipment and great skill, rather than anything supernatural. I am interested by the intersection of engineering and perception, by the science of make-believe, by dissimulation, by experiences that highlight their artificiality and precisely within it question our understanding of what is normal or natural."

SELECTED GROUP EXHIBITIONS: Mexican Pavilion, Venice *Biennale*, 2007; *Plataforma*, Fábrica La Constancia, Puebla, 2006; Sydney *Biennial*, 2006; ARCO art fair, Spain, 2006; *Dataspace*, Laboratorio Alameda, Mexico 2005; *Art Basel Unlimited*, Switzerland, 2005; *Loop* video art festival, Galería Metropolitana, Barcelona, 2004; Shanghai *Biennial*, 2004; *Open: New Designs for Open space*, Van Alen Institute, New York, 2003; Liverpool *Biennial*, 2002; *Emoção Art.ficial*, Itau Cultural, Brazil, 2002; Istanbul *Biennial*, 2002; Havana *Bienal*, 2000; *File*, Museum of Image and Sound, São Paulo, 2000; *Yo y mi Circunstancia (Me and My Circumstance)*, Musée des Beaux Arts, Montréal, 2000; *Medienkunstpreis*, ZKM, Karlsruhe, 2000; *Remote Sensations*, Ars Electronica Festival, Linz, 1997.

PUBLIC ART: *33 Questions per Minute*, Spots Mediafaçade, with realities:united, Postdamer Platz 10, Berlin, 2006; *Under Scan*, a public art commission for East Midlands Development Agency, 2005–6; *Vectorial Elevation*, for the Expansion of the European Union in Dublin, 2004; *Amodal Suspension*, opening project of the Yamaguchi Center for Art and Media, Yamaguchi, Japan, 2003; *Body Movies*, for the Cultural Capital of Europe Festival in Rotterdam, 2001; *Vectorial Elevation*, Zócalo Square, Mexico City, for the Millennium Celebrations, 2000.

AWARDS: BAFTA British Academy Award for interactive art, London, 2005 and 2002; Trophée des Lumières, Lyon 2003; Rockefeller fellowship, 2003; Rave Award, *Wired* Magazine, 2003; First Prize, International Bauhaus Awards, Dessau, Germany, 2002; Design Review 2002 Gold Award, *I.D. Magazine*, 2002; Canada Council grants, 2001; Golden Nica award, Prix Ars Electronica, Austria, 2000; award of distinction at the SFMOMA Webby Awards, San Francisco, 2000; and Excellence Prize, CG Arts Media Art Festival, Tokyo, 2000.

teresa margolles

BORN 1963, CULIACÁN, SINALOA; LIVES IN MEXICO CITY
EDUCATION: B.A. IN FORENSIC MEDICINE AND SCIENCE OF COMMUNICATION, 1995,
UNIVERSIDAD NACIONAL DE MÉXICO

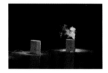

"Since the start of my career early in the 90s, I have been working on an aesthetic approach less about death than about corpses in their various phases and their socio-cultural implications. I work on lifeless bodies, with what is decaying, and always start with the question: 'How much does a corpse experience?' I, too, have gone through various phases. I began by showing the corpse in terms of direct violence. Finally I came to the cleansing of objects, which I let express a symbolic content or other factors."

—From *Teresa Margolles*, exhibition catalogue (Kunsthalle Wien, 2003), pp. 19–20.

SELECTED SOLO EXHIBITIONS: *127 Cuerpos*, Kunstverein für die Rheinlande und Westfalen, Düsseldorf, 2006; *Detonantes*, Espacio OPA, Guadalajara, Mexico, 2005; *Involution*, Centre d'Art Contemporain de Brétigny, Brétigny/Paris, 2005; *Muerte sin fin*, Museum für Moderne Kunst, Frankfurt, 2004; *Crematorio*, Galeria Enrique Guerrero, Mexico City, 2003; *Fin*, La Panaderia, Mexico City, 2002; *Aire*, Art Palace, Madrid, 2002; *Vaporización*, ACE Gallery, Mexico City, 2001; *Andén*, Cali, Colombia, 1999.

SELECTED GROUP EXHIBITIONS: Liverpool *Biennial*, 2006; *Indelible Images*, Museum of Fine Arts, Houston, 2005–6; *Baltic Triennial of International Art*, CAC Vilnius, Lithuania, 2005; Prague *Biennale*, 2005; *Eco: Arte Contemporáneo Mexicano*, Museo Nacional Centro de Arte Reina Sofia, Madrid, 2005; *Trienal Poligráfica de San Juan*, Puerto Rico, 2004; 2nd Auckland *Triennial*, New Zealand, 2004; *Casas en Acción*, Casa de América, Madrid, 2004; *Die Zehn Gebote*, Deutsches Hygiene-Museum, Dresden, 2004; *Made in Mexico*, U.C.L.A. Hammer Museum, Los Angeles, and Institute of Contemporary Art, Boston, 2004; Gwangju *Biennial*, China, 2004; *Göteborgs Internationella Konstbiennal*, Sweden, 2003; *Fuera de campo*, ExTeresa Arte Actual, Mexico City, 2003; *Stretch*, Power Plant, Toronto, 2003; *Bankett*, ZKM, Karlsruhe, 2003; *20 Million Mexicans Can't Be Wrong*, John Hansard Gallery, Southampton, and South London Gallery, London, 2002–3; *Entre Lineas*, Casa Encendida, Madrid, 2002; *Mexico City: An Exhibition about the Exchange Rates of Bodies and Values*, P.S.1 Contemporary Art Center, New York, and Kunst-Werke, Berlin, 2002; Havana *Bienal*, 2000; 4th *Biennale d'Art Contemporain de Lyon*, 2000.

AWARDS: National Creative Art System award, Mexican National Art Fund (FONCA), 2003 and 2001; first place, 7th Cuenca *Bienal*, Ecuador, 2002.

oscar muñoz

BORN 1951, POPAYÁN, COLOMBIA; LIVES IN CALI, COLOMBIA

Does your work relate in a direct or indirect way to the historical Phantasmagoria shows, or with the tradition of the shadow theater? If so, how? If not, how does it reflect on absence, loss, or death?

"Not in a direct manner. My work, I believe, has a more direct relation with the specular than with shadows, but I love the story by Pliny the Elder of the origins of painting in Greece: according to him, in its beginnings, Representation consisted of circumscribing the silhouette of the shadow of a man projected on a wall. This is by itself a fantastic and phantasmatic metaphor of representation: a presence that is constructed by its absence."

Were you familiar with the *Phantasmagoria* shows of the late 18th and early 19th century?

"I have seen the designs of a nineteenth-century projector called Phantascope that was used to make specters and phantoms appear. Woody Allen sets this atmosphere in his film *Shadows and Fog*, where the scenes with mirrors in a circus are not gratuitous. But what I did have a contact with were the fairground spectacles that came to Cali when I was a kid, which could very well be derived from the nineteenth-century *Phantasmagoria* shows. I was attracted to these spectacles in a very special way, with a mixture of fear and fascination; even if they were not very elaborate, they always succeeded in capturing me. Of all the attractions that these fairs offered, I preferred things like the show with projections on veils where a woman vanished and was replaced by a gorilla—a kind of inverted and fleeting Darwinism; or the *Arabic Labyrinth*, a structure made with repetitive modules in glass and mirrors, where one could lose itself for hours in one's own reflections, without finding a way out. I have often thought of building someday one of these labyrinths."

SELECTED SOLO EXHIBITIONS: *Proyecto para un Memorial*, Iturralde Gallery, Los Angeles, 2005; *Tres video proyecciones*, NA (B) Room, Madrid, 2004; Museo de Arte Moderno, Buenos Aires, 2003; TEORéTICA, San José, Costa Rica, 2003; *Eclipse*, Galería Santa Fe, Planetario Distrital, Bogotá, Colombia, 2001.

SELECTED GROUP EXHIBITIONS: Venice *Biennale*, 2007; Venice *Biennale*, 2005; *Cantos, Cuentos Colombianos*, Daros-Latinamerica, Zurich, 2005; *Indelible Images*, Museum of Fine Arts, Houston, 2005; *Biennale for Contemporary Art*, National Gallery, Prague, 2005; *Retratos: 2000 Years of Latin American Portraiture* (traveling exhibition: El Museo del Barrio, New York; San Diego Museum of Art; Bass Museum of Art, Miami Beach; National Portrait Gallery, Smithsonian Institution, Washington, D.C.; San Antonio Museum of Art, 2004–6); *Trienal Poligráfica de San Juan*, Puerto Rico, 2004; Cuenca *Bienal*, Ecuador, 2004; *O.K. America*, Apexart, New York, 2004; *S(HOW)*, Institute of Contemporary Art, University of Pennsylvania, Philadelphia, 2003; *Stretch*, Power Plant, Toronto, 2003; *Entrelineas*, La Casa Encendida, Madrid, 2002; *Photographic Memory & Other Shots in the Dark*, Galeria de la Raza, San Francisco, 2002; *Oxygen*, White Box, New York, 2002; *Amnesia: New Art from South America* (traveling exhibition: Contemporary Art Center, Cincinnati; Biblioteca Luis Ángel Arango, Bogotá; Contemporary Art Museum of South Florida, Tampa; Bronx Museum of the Arts, Bronx, New York; Chistopher Grimes Gallery–Track 16 Gallery, Los Angeles, 1998–99); Havana *Bienal*, 1997; Kwangju *Biennial*, South Korea, 1994; São Paulo *Bienal*, 1987.

AWARDS: Colombian National Prize in the Arts, 2004.

julie nord

BORN 1970, COPENHAGEN, DENMARK; LIVES IN COPENHAGEN

EDUCATION: GRADUATED 2001, ROYAL DANISH ACADEMY OF ART, COPENHAGEN

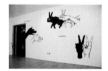

Does your work relate in a direct or indirect way to the historical Phantasmagoria shows, or with the tradition of the shadow theater? If so, how? If not, how does it reflect on absence, loss, or death?

"The drawing *The Hands* relates to shadow theater in a very innocent and childish way. It's about the very simple shadowplays that take place in almost every children's room when the nightlamp is lit. Hands performing shadows of wolves, rabbits and dragons. Here the illusion of shadows degenerates into a hallucination going wild (clichés of horror and the absurd). The shadows overrule the hands that made them!

"In general, my works are about questioning, sometimes critically deranging the notion of reality. I work with very well-known pictures and stories, mixing them up in a way so that the ordinary idea of dualism, object-subject, real and imagined, good and evil, life and death, ends up looking like absurd mental constructions without any sense—hence giving the opportunity to new perceptions and conscience."

SELECTED SOLO EXHIBITIONS: *The Cycle*, Fundación "la Caixa," Barcelona, 2004; *From Wonderland with Love*, ARoS (Aarhus Kunstmuseum), Aarhus, Denmark, 2003; *Apparitions*, Mogadishni, Copenhagen, 2003.

SELECTED GROUP EXHIBITIONS: *Girlpower & Boyhood*, Talbot Rice Gallery, Edinburgh, 2006; *MALM 2*, Malmö Kunsthal, Sweden, 2006; *Forever Young Land*, Museum of Contemporary Art, Shanghai, 2006; *Ultra New Vision of Contemporary Art*, Singapore Art Museum, 2006; *Highlights*, National Museum of Fine Arts, Copenhagen, 2005; *Fairy Tales Forever*, ARoS (Aarhus Kunstmuseum), 2005; *The Shadow*, Vestsjællands Museum of Art, 2005; *Wonderland, It's Beautiful*, Kunsthaus Baselland, Basel, 2005; *Bison Caravan*, De Watertoren, Vlissingen, 2004; *Posters Videos and Other Stuff*, Consulta / Santa Monica, Barcelona, 2004; *Artissima*, Turin, 2004; *The Petting Zoo*, Art Basel, Miami Beach, 2003; *International Women's Art Festival*, Aleppo, Syria, 2002.

rosângela rennó

BORN 1962, BELO HORIZONTE, BRAZIL; LIVES IN RIO DE JANEIRO
EDUCATION: B.S., 1986, ESCOLA DE ARQUITETURA, UNIVERSIDADE FEDERAL DE MINAS GERAIS,
BELO HORIZONTE; B.F.A., 1987, ESCOLA GUIGNARD, BELO HORIZONTE; PH. D. IN FINE ART,
1997, ESCOLA DE COMUNICAÇÕES E ARTES, UNIVERSIDADE DE SÃO PAULO

Does your work relate in a direct or indirect way to the historical Phantasmagoria shows, or with the tradition of the shadow theater? If so, how? If not, how does it reflect on absence, loss, or death?

"Smoke and images simultaneously appear and disappear, prompting a feeling that the image is the effect of an ephemeral materiality—or almost immateriality—of the curtain. This work pays homage to the illusionists and creators of the moving image. [My installation] *Experiencing Cinema* was conceived as an experiment in the archeology of cinema and particularly refers to the first 'voyages of image,' produced with elementary projectors and magic lanterns in the sixteenth and seventeenth centuries.

"The inexorable and relentless passage of time is still and ever more powerful than all the technology mankind can produce nowadays for imitating or holding back the experience of life. Time dissolves and dissipates memory, like a cloud of smoke. Even the image is not immortal."

SELECTED SOLO EXHIBITIONS: MAMAM, Recife, 2006; *Corpo da Alma/Apagamentos*, Centro Cultural São Paulo, Brazil, and Cristina Guerra Contemporary Art, Lisbon, 2004–5; *Experiência de Cinema*, Galeria Vermelho, São Paulo, and ARCO, Madrid, 2004–5; *Layed Down Little Balls*, billboard project, Galeria de la Raza, San Francisco, 2003; *O Arquivo Universal e Outros Arquivos*, Centro Cultural Banco do Brasil, Rio de Janeiro, and Centro Cultural São Paulo, 2003–4; *Survey Exhibition*, Museu de Arte da Pampulha, Belo Horizonte, 2002; *Vulgo [Alias]*, Australian Centre for Photography, Sydney, and Lombard-Freid Fine Arts, New York; Galeria Camargo Vilaça, 1998–99; *Cicatriz*, Museum of Contemporary Art, Los Angeles, 1996.

SELECTED GROUP EXHIBITIONS: *Mam (na) Oca*, Oca, São Paulo, 2006; *The Hours*, Irish Museum of Modern Art, Dublin, 2005; *Erótica: Os Sentidos da Arte*, Centro Cultural Banco do Brasil, São Paulo, 2005; *La Miranda*, Biblioteca Luis Ángel Arango, Bogotá, 2005; *Nous Venons en Paix . . . —Histoire des Amériques (We Come in Peace . . . —Histories of the Americas)*, Musée d'Art Contemporain de Montreal, 2004; Venice *Biennale*, 2003; *Strange Days*, Museum of Contemporary Art, Chicago, 2003; *Thisplay*, La Colección Jumex, Ecatepec de Morelos, Mexico, 2002; *El Final del Eclipse*, Fundación Telefônica, Madrid, 2001; *Biennial for Contemporary Art*, Berlin, 2001; *Brasil + 500 anos*, Fundação Bienal de São Paulo, 2000; *Cocido y Crudo*, Museo Nacional Centro de Arte Reina Sofia, Madrid, 2000; São Paulo *Bienal*, 1998; Kwangju *Biennale*, 1997; Havana *Bienal*, 1997; Johannesburg *Biennale*, 1997; *InSITE*, San Diego, 1997; São Paulo *Bienal*, 1994; Havana *Bienal*, 1994; Venice *Biennale*, 1993.

AWARDS: 13th Festival Internacional de Arte Electrônica Videobrasil, 2001; John Simon Guggenheim Foundation grant, 1999; Marc Ferrez prize in photography, 1992.

regina silveira

BORN 1939, PORTO ALEGRE, BRAZIL; LIVES IN SÃO PAULO
EDUCATION: B.F.A., 1959, UNIVERSIDADE FEDERAL DO RIO GRANDE DO SUL; M.A., 1980,
PH.D., 1984, ESCOLA DE COMUNICAÇÕES E ARTES, UNIVERSIDADE DE SÃO PAULO

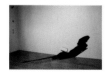

Does your work relate in a direct or indirect way to the historical Phantasmagoria shows, or with the tradition of the shadow theater? If so, how? If not, how does it reflect on absence, loss, or death?

"From the eighties on, a great part of my work is much indebted to the magical, immemorial and pluridisciplinary imaginary universe of those 'apparitions.' The luminous 'phantoms' and shadows without referent generated by diverse optical artifices in order to provoke a sense of the 'marvelous' and unexpected had always a great capacity of fertilizing my imagination.

"For me, the anamorphoses, the shadows projected by absent elements and the perspectival distortions, with vanishing points that multiply *en abime*, are also phantasmagorias, forms of enigmatic images or paradoxical spaces that can destabilize perception. During many years, I have studied and explored the territories of the vast historical paradigm of images conceived as artifices for producing illusions and phantasmagorias. Many of my installations, as well as some of the luminous images that I have projected in urban contexts at night, are fictions that I construe in order to bring into the present this same imagery, motivated by poetic affinity."

SELECTED SOLO EXHIBITIONS: Centro Cultural de España, Montevideo, Uruguay, 2004; *El Cubo*, Sala de Arte Público Siqueiros, Mexico City, 2004; *ClaraLuz*, Centro Cultural Banco do Brasil, São Paulo, 2003; *To Be Continued*, NIU Art Museum, Northern Illinois University, Chicago, 1997; *Grafias*, Museu de Arte de São Paulo Assis Chateaubriand, São Paulo, 1996; *In Absentia (Stretched)*, Queens Museum of Art, New York, 1992; and *Projectio*, Fundação Calouste Gulbenkian, Lisbon, 1988.

SELECTED GROUP EXHIBITIONS: Taipei *Biennial*, 2006; *Lumen*, Museo Nacional Centro de Arte Reina Sofía, Madrid, 2005; *The Shadow*, Vestsjaellands Kunstmuseum, Sorø, Denmark, 2005; *Indelible Images*, Museum of Fine Arts, Houston, 2005; *Nous Venons en Paix . . . —Histoire des Amériques (We Come in Peace . . . — Histories of the Americas)*, Musée d'Art Contemporain de Montréal, 2004; *Trienal Poligráfica de San Juan*, Puerto Rico, 2004; *Arte/Cidade*, 2002; *Brazil: Body and Soul*, Guggenheim Museum, New York, 2001; *Re-Aligning Vision: Alternative Currents in South American Drawing*, Miami Art Museum, Florida, 2001; *Mercosul Visual Arts Biennial*, Porto Alegre, Brazil, 2001; São Paulo *Bienal*, 1998; *India International Triennial*, New Delhi, 1991; Havana *Bienal*, 1984; *Arte/Cidade*, 1984; São Paulo *Bienal*, 1983; São Paulo *Bienal*, 1981.

AWARDS: Sérgio Motta Prize for Art and Technology, 2000; Fulbright Foundation grant, 1994; Pollock-Krasner Foundation grant, 1993; John Simon Guggenheim Foundation grant, 1990.

exhibition checklist

Note: height precedes width precedes depth; all dimensions provided
are for unframed work unless otherwise specified.

Christian Boltanski
La Danseuse (*The Dancer*), 1987
Doll, mechanical plinth, projector
Dimensions variable
Courtesy Marian Goodman Gallery, New York/Paris

Jim Campbell
Library, 2004
L.E.D. screen with attached Plexiglas and photogravure
26 ¼ x 31 ½ x 3 in. (66.7 x 80 x 7.6 cm)
Courtesy Bryce Wolkowitz Gallery, New York

Michel Delacroix
Lisetta, Ferdinand, Saverio, Edward, 1995
Metal, plastic, engraved mirrors, water and spotlight
Four pieces, each 73 ¼ x 16 ½ x 16 ½ in. (186 x 42 x 42 cm)
Collection of Miguel Angel Corzo, Philadelphia

Laurent Grasso
Untitled (Projection), 2005
Single-channel rear projection with sound, transferred to DVD,
3 mins.
Dimensions variable
Courtesy Galerie Chez Valentin, Paris

Jeppe Hein
Smoking Bench, 2003
Fog machine, bench (stainless steel and leather), mirror
Bench: 17 ⅝ x 19 ⅝ x 19 ⅝ in. (45 x 50 x 50 cm);
mirror: dimensions variable
Courtesy Johann König, Berlin

William Kentridge
Shadow Procession, 1999
Single-channel projection (35mm film with sound, transferred
to DVD), 7 mins.
Courtesy the artist and Marian Goodman Gallery, New York

Rafael Lozano-Hemmer
Sustained Coincidence (*Subsculpture 8*), 2007
Installation with incandescent bulbs controlled by
computerized surveillance system
Dimensions variable
Collection of the artist; courtesy OMR Gallery, Mexico City

Teresa Margolles
Aire (*Air*), 2002
Five humidifiers, water, antiseptic solution, and organic material
Dimensions variable
Collection of the artist; courtesy Peter Kilchmann Gallery, Zurich

Oscar Muñoz
Aliento (*Breath*), 2000
Nine metallic mirrors screen-printed with silicone emulsion
Overall dimensions variable
Steel discs: each, diam. 7 ⅞ in. (20 cm)
Collection of the artist

Julie Nord
The Hands, 2007
Site-specific wall drawing
Dimensions variable
Collection of the artist and Mogadishni Gallery, Valby, Denmark

Rosângela Rennó
Experiencing Cinema, 2004
DVD, fog machine, photographic projection on smoke wall
Dimensions variable
Courtesy Galeria Vermelho, São Paulo

Regina Silveira
Transitorio/Durevole (*Transitory/Lasting*), 1997
Self-adhesive vinyl, book
90 x 63 x 46 in. (230 x 160 x 117 cm)
Courtesy Galeria Brito Cimino, São Paulo

lenders to the exhibition

Miguel Angel Corzo, PHILADELPHIA

Galeria Brito Cimino, SÃO PAULO

Galerie Chez Valentin, PARIS

Marian Goodman Gallery, NEW YORK / PARIS

William Kentridge

Johann König, BERLIN

Rafael Lozano-Hemmer

Teresa Margolles

Mogadishni Gallery, VALBY, DENMARK

Oscar Muñoz

Julie Nord

Galeria Vermelho, SÃO PAULO

Bryce Wolkowitz Gallery, NEW YORK

photo credits